Padua in the
1450s
Marco Zoppo and his
Contemporaries

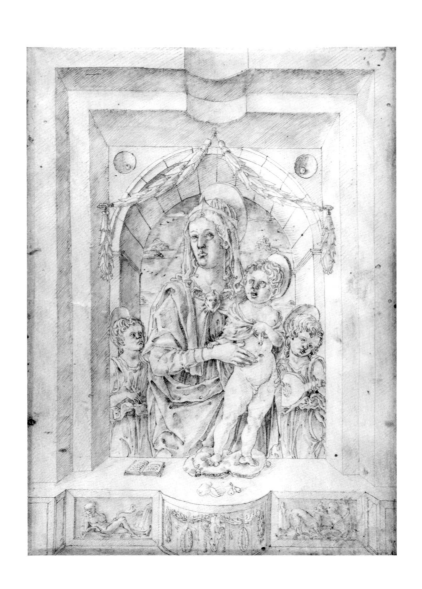

Padua in the 1450s

Marco Zoppo and his Contemporaries

Published for the
Trustees of the British Museum
by British Museum Press

Illustration Acknowledgements

The author and publishers are grateful to the following for permission to reproduce illustrations of which they own copyright:

Alinari, Florence: figs 1, 2, 11; Ashmolean Museum, Oxford: cat nos 3a–d, 4; British Library: cat. no. 2; Christie's, London: fig. 22; Gemäldegalerie, Berlin: fig. 5; Metropolitan Museum of Art, New York: fig. 6; National Gallery, London: cat. no. 12; National Gallery of Art, Washington D.C.: fig. 9; Réunion des Musées Nationaux: fig. 7; Silvano Editoriale d'Arte, Milan/Amilcare Pizzi SpA: fig. 10, taken from *La Cappella Ovetari della Chiesa degli Eremitani*, 1978; Städelsches Kunstinstitut, Frankfurt: fig. 12; V&A Picture Library: figs 3, 4.

First published in 1998 by British Museum Press
A division of The British Museum Company Ltd
46 Bloomsbury Street, London WC1B 3QQ

A catalogue record for this book is available from the British Library

ISBN 0-7141-2616-0

Designed by James Shurmer

Typeset in Sabon by James Shurmer

Printed in Great Britain by BAS Printers Ltd

Frontispiece: Marco Zoppo, *Virgin and Child* (fig. 8)

Contents

Preface

In 1995 the Department of Prints and Drawings in the British Museum was the grateful recipient of the very first grant awarded by the newly established Heritage Lottery Fund for any work of art for any British institution. We were also aided by a very substantial grant from the National Art Collections Fund.

The object of their generosity was appropriately splendid – a double-sided drawing by the Paduan Renaissance artist Marco Zoppo. This is by far the most expensive acquisition the Department has ever made. The drawing was offered to us through the kindness of its former owner, whom we have to thank, as well as Christie's, who helped steer it in our direction. There was also a substantial reduction in the gross price through the operation of the long-standing procedures relating to works of art that have been exempted from capital transfer tax.

None the less, all this would have been to no avail had we not been able to raise a very large sum of money. Indeed, in the days before the Heritage Lottery Fund was established it would have been unthinkable for us even to consider purchasing the drawing. After several decades of being forced to stand aside and watch while outstanding and expensive old master drawings that appeared on the market were exported from this country, it has been very heartening to be able to acquire a beautiful and evocative drawing that any museum or gallery in the world would be proud to possess.

The drawing finds an exceptionally appropriate home in the British Museum, where it joins the largest group of related works to be found anywhere. We have long owned an album of drawings by Zoppo, together with two similar albums of finished compositions, one by Jacopo Bellini, the other the so-called *Florentine Picture Chronicle*. We also acquired in 1976, in lieu of estate duty, a most important study by Mantegna for his fresco in the Ovetari chapel which shows precisely the same subject – St James on his way to execution – as one side of the new Zoppo drawing.

The idea to mount a small exhibition to celebrate the new acquisition and to put it into its context within Padua and Italian Renaissance drawing was suggested by Hugo Chapman, our specialist in Italian art. Originally we only envisaged a display with an accompanying leaflet. That we have been able to produce something much more substantial is entirely due to the generosity of

Thomas Williams, who provided the subsidy that has enabled us to publish this extended essay and catalogue. It has had to be written and printed at great speed, and I am grateful to Hugo Chapman for his labours in writing it so swiftly, and to British Museum Press for agreeing so readily to take it on.

Our thanks are also due to those who have helped us with loans, texts and advice. Hugo Chapman wishes me to thank Dr Janet Backhouse at the British Library, Dr Christopher Brown at the National Gallery, Dr Timothy Wilson at the Ashmolean Museum and Mr Paul Williamson at the Victoria and Albert Museum for agreeing to lend works to the exhibition. Jeremy Warren has kindly written the entries for the sculpture. Giovanna Brambilla and Mirta Oregna, who both worked as volunteers in the Department, were enormously helpful at the initial stages of the project. Another volunteer, Richard Woodward, has greatly aided the task of researching the entries and checking the references. He and Martin Royalton-Kisch have made many improvements to the text. Our thanks are also due to Joanna Champness and James Shurmer, the editor and designer of the catalogue, and to the Departmental photographer Bill Lewis.

Finally, I would like to repeat the thanks of the Trustees of the British Museum to the Heritage Lottery Fund and the National Art Collections Fund, who made the acquisition possible. We hope that they will find this publication an appropriate gesture of gratitude, and a demonstration that acquisitions do not merely add to collections, but lead to the scholarship and understanding that alone can further public education and enjoyment.

ANTONY GRIFFITHS
Keeper, Department of Prints and Drawings

Marco Zoppo: Biographical Outline

1432/3

Marco Ruggeri, called Marco Zoppo on account of his lameness (*zoppo* being the Italian for lame) is born in Cento, a small town between Bologna and Ferrara. His father Antonio was a notary, a profession which three of his five sons followed. The date of his birth is calculated on the basis of a document of May 1455 (see below), which states that he is twenty-three years old.

1452

The first mention of Zoppo as an artist. He is paid to gild and restore a wooden statue of the *Madonna and Child* formerly in the church of Santa Maria in Pieve di Cento and now in the Pinacoteca Comunale di Pieve di Cento.[1] The payment for this work describes Zoppo as *maestro* and *depintore* [master and painter], which would suggest that he had completed his training. Nothing is known of where or to whom Zoppo was apprenticed. However, in view of his family's connections with Bologna, and the fact that he later signed himself 'Zoppo da Bologna', it is likely that he learnt his craft there.

24 May 1455

Zoppo is adopted as the son and heir of the Paduan painter Francesco Squarcione. According to the document, Zoppo has been in the artist's studio for about two years, that is from the summer of 1453. The exact period, however, is unclear, as a later document states that he began to work in Squarcione's studio in April 1454.

During his period with Squarcione he paints a *Madonna and Child*, often called the *Wimborne Madonna* after its former owners, which is now in the Louvre, Paris (fig. 7).[2] The small coat-of-arms on the parapet are those of the Dardani, a Venetian family who had branches in Padua and Verona. The panel is signed 'opera del Zoppo di Squarcio/ne'. A small and poorly preserved painting of the *Madonna and Child with saints and two donors* in the Muzeul National de Arta al României, Bucharest,[3] which is inscribed 'Madonna del zopo [*sic*] di Squarcione', may be a copy after an early work by Zoppo.

9 October 1455

Zoppo, now resident in Venice, annuls his recent adoption by Squarcione. Two documents record an arbitration in which Zoppo is awarded twenty gold ducats in repayment for the work he had executed in Squarcione's studio.

1461–2

The artist's documented period in Bologna. During this time he is recorded as having been paid for minor decorative work in the Basilica of San Petronio. On 16 September 1462 Zoppo writes a letter from Bologna to Barbara Gonzaga, Marchesa of Mantua, in which

he discusses the commission of two pairs of painted chests (*cassoni*) which she wishes him to complete by Christmas. One of the reasons he gives for his delay in finishing this work is that he is already occupied with painting another pair for a Bolognese lady.

In Bologna he paints the *Crucified Christ* in the church of San Giuseppe fuori Porta Saragozza,[4] and the polyptych of the *Madonna and Child with saints* for San Clemente, the church of the Collegio di Spagna.[5] Both works are still *in situ*.

1468

According to the sixteenth-century Venetian historian Francesco Sansovino, Zoppo's altarpiece, formerly in the church of Santa Giustina in Venice, dates from this year. Four panels of half-length saints, all with gold backgrounds, probably formed part of this work. These panels are: *A bishop saint reading* (National Gallery, London); *Saint Jerome* (Walters Art Gallery, Baltimore); *Saint Peter* (National Gallery of Art, Washington); *Saint Paul* (Ashmolean Museum, Oxford).[6]

1471

The Madonna and Child with saints in the Staatliche Museen, Berlin,[7] which was originally the central panel of the dismembered altarpiece in the church of San Giovanni Battista in Pesaro, bears this date – 'Marco Zoppo da Bolo/gnia pinsit MCCCCLXXI/ī(N) Vinexia'. Five other panels can be convincingly related to the same altarpiece, the *Dead Christ supported by angels* (Museo Civico, Pesaro), which was above the main panel, and from the predella, *Saint John the Baptist* (Fondazione Cini, Venice); *The stigmatisation of Saint Francis* (Walters Art Gallery, Baltimore); *Saint Jerome in the wilderness* (Pinacoteca Nazionale, Bologna); and the circular *Head of Saint John the Baptist* (Museo Civico, Pesaro).[8]

1473

In Venice Zoppo acts as a witness to the will of Francesco Trevisan, a Venetian who lives in the same quarter of the city.

1474–5

A letter written to Zoppo in Venice by the humanist and scribe Felice Feliciano is included in a collection of letters compiled in this period. In his letter Feliciano likens Zoppo to the ancient painter Euphranor and says that he would visit the artist but is put off from doing so by the latter's ferocious dogs.

1478

Marco Zoppo dies, aged forty-six, in Venice. The date is known from a letter of that year to Doge Agostino Barbarigo which mentions a legal dispute between one of Zoppo's daughters and her aunt, the wife of Zoppo's brother Giovanni, who was also a painter.

Introduction

The present exhibition focuses on a large and highly finished double-sided pen and ink drawing on vellum (cat. no. 8) by the Emilian artist Marco Zoppo, which was acquired in 1995 from the Colville family. It is the earliest known drawing by the artist and is datable on stylistic grounds to the second half of the 1450s, at the end of Zoppo's short but formative period in Padua where he had been a pupil of Francesco Squarcione. The city was the leading artistic centre in northern Italy in the mid-fifteenth century, due in large part to the ten-year sojourn in the city of the Florentine sculptor Donatello, who arrived there in 1443. Donatello's stay coincided with the emergence of a native painter of genius, Andrea Mantegna, whose first independent commission dates from 1447. This period of artistic pre-eminence was a relatively short one – its end marked by the departure of Mantegna in 1460 to serve the Gonzaga family in nearby Mantua. Without the creative impulse of Donatello and Mantegna the city quickly ceased to be a centre of artistic innovation, but Padua's artistic legacy was nevertheless a durable one. The influence of the distinctive style of painting and drawing which had developed there during the 1440s and 1450s can be detected in the work of a number of the most progressive artists working in Venice, Verona, Ferrara and in other cities in northern Italy at that time and subsequently. Like Zoppo, they had gravitated to Padua because of the unrivalled opportunity the city afforded of studying works in the modern style.

The British Museum drawing is a testament to the effect that Padua had on the young Zoppo, and the aim of the present exhibition is to evoke the artistic milieu which shaped his style. The wider influence of Paduan art is also addressed, within the limitations of the Museum's collection, by the inclusion of drawings by artists who were affected to varying degrees by the work they saw in the city – including Jacopo and Giovanni Bellini and Cosimo Tura. Although largely concentrating on drawings from the period, the exhibition attempts to show Zoppo's work in a broader context by the inclusion of a painting from the National Gallery attributed to Giorgio Schiavone, a fellow pupil of Squarcione, and of reliefs and plaster casts after Donatello from the Ashmolean Museum and the Victoria and Albert Museum. An exhibition of this nature can threaten to reduce a work of art to a compendium of influences, and this is even more perilous when, as in case of the ex-Colville drawing, the references to paintings and sculptures by his better-known contemporaries are so explicit. But the manner in which Zoppo interpreted and transformed artistic motifs taken from

these artists is highly individual and never descends to the level of slavishly mimetic appropriation. The full extent of Zoppo's imaginative powers can be seen in his drawings, which range from tender meditations on the theme of the Virgin and Child, to darkly humorous evocations of the violence and sexual licence of the pagan world. His inventiveness as a draughtsman has been insufficiently acknowledged outside specialist circles, and with this in mind the exhibition displays in full for the first time the matchless holdings of his drawings in the British Museum.

Zoppo's pre-Paduan Period

Zoppo was in his early twenties when he arrived in Padua, having already completed his apprenticeship either in Cento or, which is more likely, in Bologna. With no documentary record for this period it is futile to speculate on the identity of Zoppo's master, and in a sense this question is of little consequence because his artistic education in Bologna appears to have been superseded by that which he received in Squarcione's studio in Padua. Apart from a thorough training in the craft of painting Zoppo can have gained little from his first apprenticeship, for Bolognese painters in the mid-fifteenth century were still working in a late Gothic style that had changed little since the beginning of the century.[9] The adherence of the city's painters to the Gothic manner was so deeply rooted that they appear to have remained unmoved by the few examples in Bologna of works executed by Tuscan artists in the Renaissance style. Zoppo's move to Padua suggests a resistance to such insularity and it is worth enumerating some of the Renaissance works which may have revealed to him the inadequacies of his training in Bologna.

The most prominent of these were the sculptures for the main doorway of the basilica of San Petronio, executed by the Sienese sculptor Jacopo della Quercia, which had been commissioned in 1425 and left unfinished at his death in 1438.[10] The vivid naturalism of Quercia's sculptures, carved in the round and in relief, must have been particularly striking to an artist familiar with the swaying, often anatomically insubstantial figures found in contemporary Bolognese painting. Zoppo's study of Quercia is later reflected in the Christ Child in his Collegio di Spagna altarpiece, painted during his second period in Bologna in the early 1460s, whose striding pose is modelled on that of the figure in the *Virgin and Child* group above the portal.

Zoppo would also doubtless have studied Paolo Uccello's fresco of the Nativity (only a fragment of which remains)[11] painted by 1437 in the sacristy of San Martino in Bologna. How much he profited directly from the work is open to question; the Florentine painter's austere and monumental language of form may well have been beyond Zoppo's comprehension at this early stage. Similarly, his training at this point may have left him incapable of understanding, except on the most superficial level, the Florentine painter's creation of space through the use of orthogonal perspective. At the very least Uccello's painting would have highlighted with startling clarity the provincial character of contemporary Emilian painting.

Paradoxically, Zoppo may have gained a greater understanding of the modern style through a painting whose style and form were, in comparison with Uccello's fresco, much more traditional. Zoppo's time in Bologna would have coincided with the arrival in 1450 of the lavishly gilded polyptych by the Venetian brothers Antonio and Bartolomeo Vivarini, commissioned by Pope Nicholas V for the high altar of the church of San Gerolamo alla Certosa. The work, now in the Pinacoteca Nazionale in Bologna,[12] is entirely Gothic in form but includes more advanced elements in the representation of space and volume which show an awareness of more recent models. Antonio Vivarini, with his earlier collaborator Giovanni d'Alemagna, had been one of the artists commissioned by the heirs of Antonio Ovetari to decorate his chapel in the church of the Eremitani in Padua, and there he would have seen the work of Andrea Mantegna and Niccolò Pizzolo. The spatial play of the Virgin's throne, which appears both to thrust forward from the picture plane and to recede into the altarpiece, is a faint echo of the daring illusionism that Antonio Vivarini had seen in Padua. The experimentation in the Certosa altarpiece is on a limited scale, but even so it is far in advance of anything painted by an Emilian painter of the period.

Zoppo's move to Padua postdates the end of his apprenticeship, for as we have seen, the contract of 18 June 1452 relating to the gilding of a statue of a Madonna and Child in Pieve di Cento describes him as *maestro* and *depintore* (master and painter). Within a year or two of this minor commission Zoppo had gone to Padua, sometime between the summer of 1453 and the beginning of 1454.

The City of Padua

Padua was renowned throughout Europe for being the seat of a venerable university, founded in 1222 by a group of Bolognese students and professors of law, and as a place of pilgrimage, because Saint Anthony of Padua, the great Franciscan preacher who was canonised a year after his death in 1231, was buried in the church of Sant'Antonio. Padua was also proud of its ancient heritage, for like Rome it claimed (according to a legend that goes back to Virgil and Livy) to have been founded by Trojans fleeing after the sack of their city. This myth was even supported by archaeological evidence. In 1283 a huge skeleton was unearthed which was identified as that of the Trojan hero Antenor and was honoured with a Gothic cenotaph in the centre of the city. The city could also boast of its Roman past as Patavium, when it had been one of the largest and most prosperous cities in the Italian peninsula. The artistic and cultural life of Padua was at its most vital during the fourteenth century, when for much of the period the city was ruled by the Carrara family. The Carrara court provided humanist patronage, attracting such notable figures as Petrarch to the city, and Padua also became one of the most important centres of painting in northern Italy. The Paduan school of painting depended on the work of the Florentine artist Giotto, whose frescoed decorations in the Arena chapel date from the first decade of the fourteenth century; and throughout the century, with the notable exception of

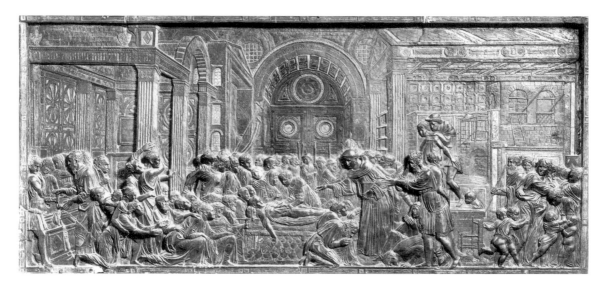

Fig. 1 Donatello, *Miracle of the miser's heart*, bronze relief from the Santo altarpiece, Padua.
57 × 123 cm

Guariento, the leading painters active in the city tended to be from elsewhere. Padua's
independence ended in 1405 when, after a long and costly war that almost halved the
city's population, it became part of the mainland empire of Venice. Through the
university the links with the Venetian social and intellectual élite were already well
established, and these ties were strengthened by a law of 1434 requiring all Venetians
who wished to attend a university to go to Padua.

The city's pride in its ancient past, fostered by its long humanist tradition, was
expressed through the revival of classical artistic forms. The antique medal, for
example, was first revived in the Renaissance period by Francesco Carrara II in 1390
to commemorate his recapture of the city, and in the same spirit the commissioning
of an equestrian bronze sculpture of Gattamelata in the following century was
clearly intended to bring to mind those from antiquity, of which that of Marcus
Aurelius (at that time identified as the emperor Constantine) in Rome was the
only survivor. The importance of antiquity to Padua's sense of civic identity is most
clearly expressed in the excitement caused by the supposed discovery in 1413 of the
tomb of the Roman historian Livy. One of the city's most illustrious early citizens, his
remains, minus the skull smashed by an alarmed monk fearing pagan idolatry, were
carried in triumph through the city. This veneration of the tangible reminders of the
city's classical past, informed by the study of classical texts, also encouraged the
collection by Paduan patricians and humanists of antique medals, coins and gems, and
the assembling of collections, known as sylloges, of antique inscriptions transcribed
from ancient buildings and tombs. The city's antiquarianism had its most profound
effect on Mantegna, whose recreation of the classical world in the Ovetari chapel

frescoes has an authority and a compelling sense of actuality unmatched by any other painter of the fifteenth century.[13] Although much of the classical flavour of Mantegna's work owes more to the artist's imagination than to archaeological observation, he did incorporate authentic details which indicate his contact with some of the city's leading antiquarians. One of the most notable of these scholar-collectors was Giovanni Marcanova, a doctor of medicine who taught in the university, who may well have helped Mantegna in the abundant epigraphic and visual quotations from antique sources that appear in the *Trial of Saint James* in the Ovetari chapel.

The diffusion of classical forms at a less elevated level can be seen in the antique flavour of lettering and decoration adopted in illuminated manuscripts by Paduan scribes and illuminators (see cat. no. 2), and in the swags and decorative putti inspired by classical reliefs which are almost a trademark of the Paduan style of painting. Although Padua's intellectual climate did not inspire the same level of antiquarian rigour in Zoppo as that shown by Mantegna, his pictorial imagination was no less fired by the example of antiquity, and it is likely, possibly through his friendship with Mantegna, that he was acquainted with two of the most classically inspired scribes in the city – Felice Feliciano and Bartolomeo Sanvito. Characteristically, Zoppo shows little interest in borrowing specific classical motifs, preferring to draw inspiration in a more general way from antique sources, as in the inventive series of heads in the Rosebery album (cat. no. 15). These are loosely based on Greek and Roman coins and in the same drawing-book he interprets in a more overtly violent and sexual manner the motif of playing putti found in Roman reliefs. His imaginative and often playful allusions to antiquity – the first expression of which is found in the fantastic Roman architecture on the *verso* of the ex-Colville drawing – is entirely in keeping with the romantic spirit of contemporary north Italian humanism, as exemplified in Felice Feliciano's famous, and most probably fictitious, account of an archaeological boating trip around Lake Garda in 1460 in the company of his friend Mantegna and two other like-minded antiquarians. According to this, the party gave themselves Roman titles and voyaged around the lake in a boat adorned with tapestries, stopping to look at classical sites and inscriptions. The tour ended with a visit to a church in Garda where they sang hymns to the 'supreme Thunderer' and to his mother for having granted them 'the wisdom and the will to seek out such delightful places and such venerable ancient monuments'.[14] Feliciano, a Veronese humanist and scribe, was one of the key figures in the revival of Roman epigraphy. A friend of Zoppo, their association probably began in Padua in the mid-1450s. He was the scribe for the second and expanded version of Marcanova's sylloge, the *Collectio Antiquitatum* (Biblioteca Estense, Modena),[15] which was finished in Bologna in 1465, and he was probably responsible for recommending Zoppo to execute a full-page drawing of ancient Rome. Zoppo's other commissions as illuminator may also have stemmed from his contact with antiquarian circles in Padua, since the scribe in both the *Epistolae ad Atticum* by Cicero (now in the Vatican)[16] and the works of

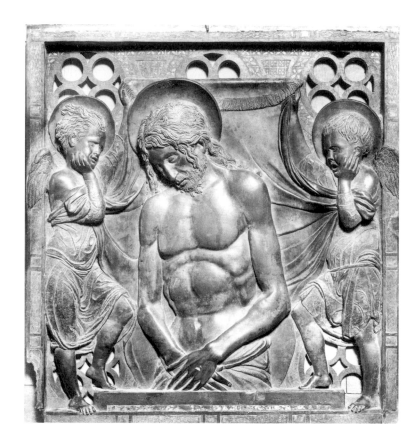

Fig. 2
Donatello, *Dead Christ mourned by two angels*, bronze relief from the Santo altarpiece, Padua. 580 × 560 mm

Virgil in the Bibliothèque Nationale in Paris[17] was the Paduan Bartolomeo Sanvito (see cat. no. 2). The latter's contact with artistic circles in the city is affirmed by the contract he drew up between the Lazzara family, the patrons of Squarcione, and the painter Pietro Calzetta in 1466 (fig. 22).[18]

Donatello in Padua

Donatello had been one of the founders of the Renaissance style along with Alberti, Brunelleschi and Masaccio in his native Florence, and he was largely responsible during his ten-year period in Padua (1443–53) for introducing it to the young generation of painters in the city. Other Florentine Renaissance artists had worked in Padua before him: Filippo Lippi in the mid-1430s and Paolo Uccello, who is recorded as having frescoed a room in the Vitaliani palace with a cycle of giants, perhaps in 1445. But in comparison with Donatello their impact on the city's artists was less significant.[19] During the sculptor's stay he was occupied with three large-scale commissions in bronze: the equestrian monument to the *condottiere* Erasmo da Narni, called Gattamelata, which was placed in the square outside the basilica of Sant'Antonio, known as the Santo (see cat. no. 1); and in the church itself a life-size

Crucifix and the high altar consisting of sculpture in the round and numerous reliefs in bronze and stone.[20]

 The work which had the greatest influence on Paduan artists was undoubtedly the Santo altar, both for its innovative format and for the variety of compositional and figural ideas in the reliefs. The appearance of Donatello's altar is unfortunately unknown because it was dismantled in 1579 and the present arrangement, which dates from the end of the last century, is generally agreed to differ fundamentally from the original. Although none of the subsequent proposed reconstructions have met with unanimous approval, it is generally agreed that the overall scheme of Donatello's altarpiece is reflected in that by Mantegna for the church of San Zeno (1456–9).[21] Donatello's six life-size standing bronze figures of saints would have been placed on either side of the central group of the seated Virgin and Child. The sculptures were enclosed in an open tabernacle of eight columns of classical form which supported a curved pediment with volutes at both ends. The sculptor clearly intended the figures to be seen as occupying a unified space and connected through gesture and emotion. This type of composition, known as a *sacra conversazione*, which powerfully enhances the sense of actuality, was pioneered in Florence in the late 1430s and 1440s by painters such as Filippo Lippi and Domenico Veneziano. It may already have been known in Padua, albeit in a less developed form, through a triptych painted by Filippo Lippi (divided between the Metropolitan Museum of Art, New York and the Accademia Albertina, Turin)[22] which appears to have been executed for a Paduan church in about 1440. The composition of Lippi's work was known to local artists, as is shown in Antonio Vivarini and Giovanni d'Alemagna's Gothicised treatment in their painting of the *Four fathers of the Church* triptych of 1446 for the Scuola della

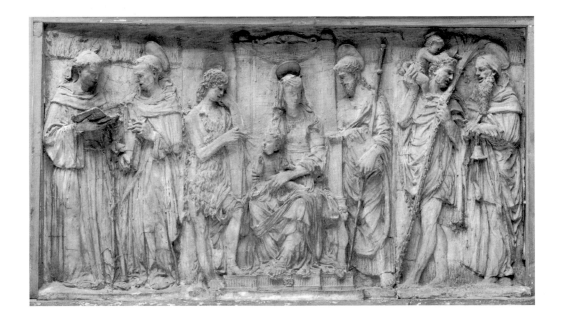

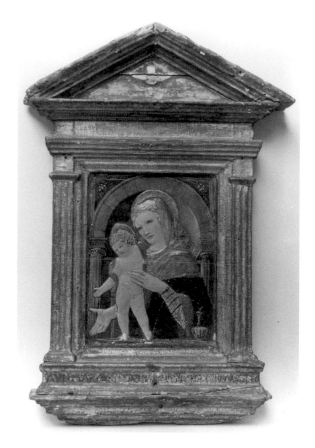

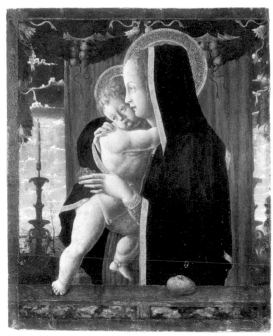

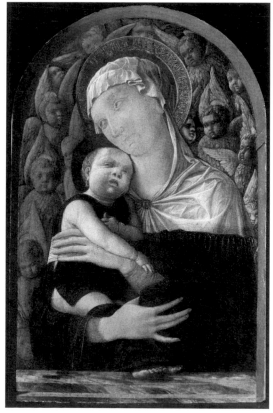

Above Fig. 4 Follower of Donatello,
Virgin and Child, relief, painted gesso.
210 × 159 mm. London, Victoria and
Albert Museum

Above, right Fig. 5 Francesco Squarcione,
Virgin and Child, tempera on panel,
820 × 700 mm. Berlin, Gemäldegalerie

Right Fig. 6 Andrea Mantegna,
Virgin and Child (The Butler Madonna),
tempera on panel, 441 × 286 mm.
New York, Metropolitan Museum.
Bequest of Michael Friedsam, 1931

Left Fig. 3 Niccolò Pizzolo, *Virgin and
Child with saints*, cast after the terracotta
relief from the altarpiece in the church of
the Eremitani, Ovetari chapel, Padua.
London, Victoria and Albert Museum

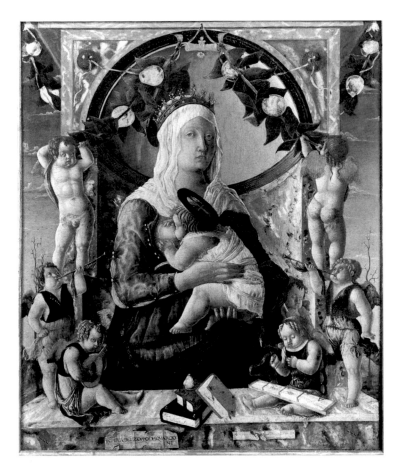

Fig. 7
Marco Zoppo,
*Virgin and Child
(Wimborne
Madonna)*, oil and
tempera on canvas,
860 × 670 mm.
Paris, Musée du
Louvre

Carità, Venice.[23] Even allowing for the difference in medium, the imposing scale and monumental grandeur of the figures in Donatello's sculpted *sacra conversazione* were, however, of a different order to any previous painted treatment of the subject, and his use of this compositional form for an altar in one of the most famous and visited churches in the north of Italy was to exert a considerable influence on the development of this theme in painting in the region.

Below the main figures, as in a predella of a painted altarpiece, Donatello placed the four rectangular bronze reliefs showing scenes from the life of Saint Anthony. These show the sculptor's extraordinary gift for dramatic narrative, the complexity of which, both in the spatial setting and the marshalling of large numbers of figures into unified groups, had never before been so successfully attempted in any medium. These qualities are exemplified in the *Miracle of the miser's heart* (fig. 1) in which the setting is a street flanked by classical porticoes that lead the eye to an imposing church door in the centre. The complex architectural background creates the impression of space extending beyond the great circular windows of the church façade and the half obscured doorway on the right. The scale of the architecture (the intricate decoration

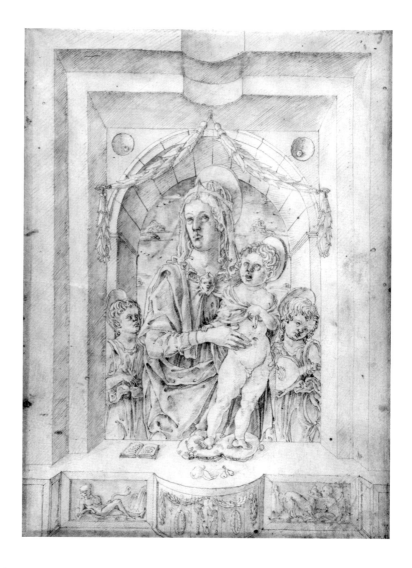

Fig. 8
Marco Zoppo,
Virgin and Child,
pen and brown ink,
brown and blue
wash, page 2 *recto*
of the Rosebery
Album,
218 × 158 mm.
London, British
Museum

of which is gilded like the other reliefs) is emphasised by the low viewpoint, an idea
taken up by Mantegna in the Ovetari frescoes, as in the *Saint James on his way to
execution* (fig. 11). Donatello's figures are confined to a narrow stage-like space in
the foreground, dominated by the tall figure of the saint directing the opening of
the corpse laid across the centre. The intense drama of the miracle is felt through the
various reactions of the crowd, ranging from the shock of the man who stoops down
to stare disbelievingly into the empty cavity, to the terror of the fleeing children on the
right. These reliefs were interspersed by twelve panels of *Music-making putti*, four
Symbols of the Evangelists and one *Dead Christ mourned by two putti* (fig. 2; a cast
is in the exhibition). At the back of the altar was a large relief of the Entombment
carved in limestone and inlaid with marble and glazed coloured strips. Some idea of
the emotional force of the work, notable for the rendering of the frenzied grief of the

women, is provided by a much smaller bronze relief copy of this composition from the Ashmolean (cat. no. 4) which is included in the present exhibition.

The innovative form of Donatello's altar with narrative reliefs below a monumental *sacra conversazione* was quickly taken up by Paduan artists. The first to do so was Donatello's former assistant in the Santo, Niccolò Pizzolo, in his terracotta altarpiece of the *Enthroned Virgin and Child with saints* in the Ovetari chapel.[24] Following Donatello's model, the main relief in Pizzolo's work is a *sacra conversazione* enclosed by a classical frame with a narrative relief below and a segmental lunette above. The altar, executed between 1449 and Pizzolo's death in 1453, suffered extensive damage when the chapel was hit by a bomb in 1944, and the main relief can now be best appreciated through a cast in the Victoria and Albert Museum (fig. 3). The composition of Pizzolo's work is strongly frieze-like, with the figures compressed into a narrow stage. No attempt is made, apart from the recession

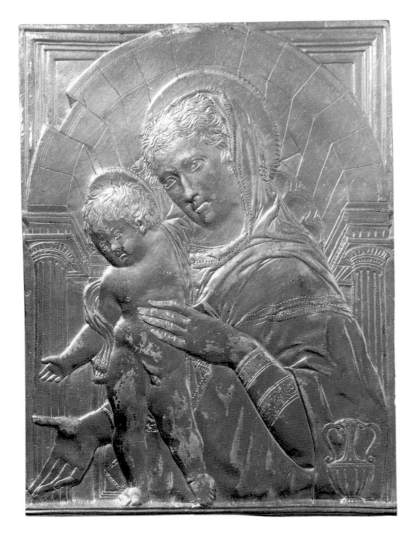

Fig. 9
Follower of
Donatello,
Virgin and Child,
bronze plaquette,
203 × 152 mm.
Washington D.C.,
National Gallery
of Art

of the Virgin's throne, to give a sense of space extending behind them. It seems likely that Zoppo studied Pizzolo's altarpiece, since the Madonna's high-backed throne decorated at the top with a swag in Pizzolo's relief was used, with some slight variations, in the painting of the *Madonna and Child with saints* in Bucharest, which is generally regarded as a copy after a work by Zoppo dating from the beginning of his apprenticeship with Squarcione. Pizzolo's relief probably also inspired the planar and richly plastic treatment of the figures in the main panel of Zoppo's Pesaro altarpiece, now in Berlin, which also incorporates the sculptor's low placement of the central throne so that the heads of the saints are above that of the Virgin. Mantegna's slightly later San Zeno altarpiece, which will be discussed later, was the first painting of its kind to be inspired in both composition and format by Donatello's work, and this in turn exerted a decisive influence on the development of the altarpiece in northern Italy.

The wealth of ideas and motifs in Donatello's Santo altar was soon utilised by Paduan painters. For example, the half-length dead Christ in Pizzolo's lost drawing for an altarpiece, known through the copy by Bartolomeo Sanvito (fig. 22), is modelled on the figure in Donatello's relief, as is Zoppo's treatment of the subject on the *recto* of the ex-Colville drawing. Single compositional motifs could also be lifted from Donatello's multi-figured compositions: in Mantegna's fresco of *Saint James and the demons* in the Ovetari chapel the fleeing youth, whose legs alone can be seen because he is obscured by a figure in front of him, derives from a figure in Donatello's *Miracle of the speaking babe*.[25] Apart from these specific borrowings no painter in Padua except Mantegna attempted to adapt Donatello's highly evolved narrative approach. Generally, however, Mantegna resisted Donatello's influence, although in certain features, such as the illusionistic creation of space in the Ovetari chapel, he clearly profited from study of the Santo reliefs. In comparison, the architectural settings in Mantegna's frescoes are simplified and the recession of space more lucid. Similarly, in contrast to the strong emotions that reverberate through the dense crowd of figures in Donatello's reliefs, the action and emotional tenor of Mantegna's frescoes are understated and articulated in the main through relatively few figures, even in scenes such as *Saint James on his way to execution* (fig. 11), a subject which offered the potential for experimentation with Donatello's compositional manner.

In addition to these major projects Donatello and his team of assistants made small-scale works for private patrons, including terracotta reliefs and bronze plaquettes of the Virgin and Child. These works, or casts after them (figs 4 and 9), circulated widely among artists in northern Italy and were used as sources for compositional ideas. The most characteristic type of painting in Padua in the 1450s and 1460s – the half-length Virgin holding the Child behind a ledge, often enshrined in a niche,[26] variants of which include Francesco Squarcione's Berlin painting (fig. 5), Mantegna's *Butler Madonna* in the Metropolitan Museum of Art (fig. 6),[27] Zoppo's early Louvre painting (fig. 7), his drawing in the Rosebery album (fig. 8), and Giorgio Schiavone's painting from the National Gallery included in the exhibition (cat. no. 12) – all

depend to a greater or lesser degree on Donatello. A specific borrowing is the Christ Child in Schiavone's painting in the National Gallery (cat. no. 12) from the bronze relief by a close follower of Donatello in the National Gallery in Washington (fig. 9).[28] Donatello's many variations on the theme were a continuing source of inspiration long after the sculptor had left the city, as can be seen from Zoppo's own versions in his dismembered 'Madonna sketchbook' (cat. nos 19–20), and from Mantegna's moving treatment of the Virgin tenderly holding the sleeping child (Berlin, Gemäldegalerie),[29] which is a pictorial equivalent of Donatello's so-called *Verona Madonna*, known from a number of terracotta replicas.[30]

Mantegna in Padua

From the early 1440s to 1460 Mantegna lived and worked in Padua. Born late in 1430 or early in 1431 in the village of Isola di Cartura a few miles north of the city, Mantegna was the son of a master carpenter. Around 1441–2 he moved to Padua when he began a six-year apprenticeship with Francesco Squarcione, then the leading painter in the city. During this period the childless Squarcione adopted Mantegna, as he was to do with other pupils including Zoppo more than ten years later.[31] This practice allowed Squarcione to profit from the work of his most talented pupils without having to reimburse them fully, while his adopted sons, in theory at least, gained from their association with an established master. By 1447 the relationship between Mantegna and his adopted father had soured and in January of the following year in Venice, where Squarcione had a house, they took their differences to two arbitrators. The latter decreed that Mantegna should receive less than half of the four hundred ducats that he had asked for in repayment for the work he had done in Squarcione's studio. This award clearly did not satisfy Mantegna and in 1455 he petitioned, this time successfully, to be awarded the full amount, although by the time the judgement arrived both artists had already amicably agreed to cancel the sum.

Even before his break with Squarcione Mantegna was receiving independent commissions. In 1447 he was asked by a wealthy baker, Bartolommeo di Gregorio, to paint the high altarpiece, now lost, for the church of Santa Sofia in Padua, a work which he had completed by the following year. In 1448 he was asked to participate in the decoration of the funerary chapel of Antonio degli Ovetari in the church of the Eremitani in Padua.[32] According to Vasari, Squarcione was initially approached to fulfil the commission himself but he passed it instead to his former pupils, Pizzolo and Mantegna. This is questionable as the quality of the other artists involved in the project – Antonio Vivarini and Giovanni d'Alemagna, who had painted one of the most forward-thinking altarpieces for the church of San Francesco Grande in Padua in 1447 – make it more likely that Antonio Ovetari's executors selected the most innovative painters available. The frescoes can now unfortunately only be appreciated through old photographs because the chapel was all but destroyed by a bomb in 1944

and apart from a few small fragments that survived the blast, only the scenes of the *Martyrdom of Saint Christopher* and the *Assumption* remained intact because they had been earlier removed due to their poor state of conservation.

According to the contract of May 1448 Mantegna and Pizzolo were to paint the frescoes of the tribune arch and the story of Saint James on the left wall, as well as execute the terracotta altarpiece which, because of Pizzolo's experience in Donatello's studio, was his work alone. Neither artist was suited by temperament to collaborative ventures and after repeated squabbling and two failed attempts to resolve their difficulties the project was divided between them in September 1449. According to this arrangement Mantegna was to paint all but one of the scenes on the left-hand

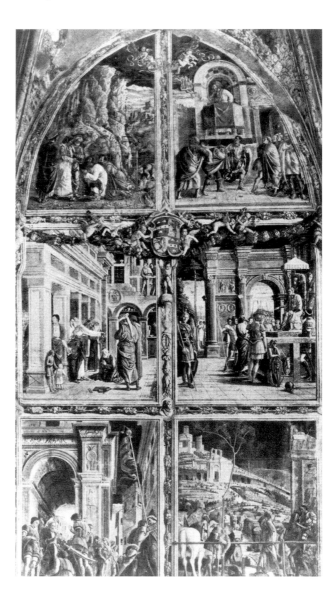

Fig. 10 View of the left-hand wall of the Ovetari chapel in the church of the Eremitani, Padua, with frescoes of Saint James by Mantegna (destroyed in 1944).

wall of the chapel with incidents from the life of Saint James, and was to be responsible for their illusionistic framework (fig.10). Pizzolo's contribution to the painted part of the chapel before his murder in 1453 was confined to the figure of God the Father in the vault of the tribune, and below this the four Fathers of the Church seen at work in their study through fictive circular windows. The effect of Pizzolo's close association with Donatello is reflected in his emphasis on volume in his representation of form and in his daring use of perspective to enhance the sense of realism. This is seen most clearly in the opened doors at the front of St Gregory's desk, which appear to project outwards into the space of the chapel. The influence of Pizzolo's sculptural style on Mantegna is apparent in the latter's early works in the chapel – the tribune vault figures and in elements of the first of the two narrative frescoes, *The calling of Saints James and John* and *Saint James preaching* (1449–51), painted in the upper register of the left-hand wall. In comparison with these, the spatial effect and the command of narrative in the two scenes in the middle register, *Saint James baptising Hermogenes* and the *Trial of Saint James* (c.1450–4), are much more assured. The two scenes are linked by a unified perspectival system and in contrast with the earlier frescoes where the action is compressed into the foreground, in these works it is moved to the middle ground, thereby amplifying the sense of space.

The classicising detail in the depiction of Roman buildings and costume in the latter two frescoes reveal Mantegna's greatly expanded knowledge of classical art. This was stimulated by his contact with Paduan humanists and also by his study of the densely detailed recreations of antique architecture contained in the albums of studies by his father-in-law, the Venetian painter Jacopo Bellini (one of two surviving examples of which is included in the present exhibition, cat.no.11), whose daughter he had married in 1453. Bellini's drawings of vast architectural vistas which reveal his command of Albertian perspective may also have inspired Mantegna's dramatic use of architecture, exemplified by the great triumphal arch (perhaps inspired by the Arco dei Gavi in Verona) which towers above the figures in the *Saint James on his way to execution* (fig. 11), one of the two scenes painted at the lowest register of the chapel, in the period 1453–7. Mantegna's compositional study for this fresco, the only surviving drawing related to the Ovetari chapel, is included in the exhibition (cat.no.7). In this and the companion scene of the *Execution of Saint James* the vanishing-point is low so that only the figures at the front are seen in their entirety. By doing this Mantegna creates the illusion that the action is taking place just above the eyeline of the viewer standing in the chapel and this is reinforced by the device, also used by Donatello in his Santo reliefs, of painting the feet of the foremost figures as if protruding beyond the edge of the platform. Mantegna's last works in the chapel were the two lower scenes on the right-hand wall, the *Martyrdom of Saint Christopher* and the *Removal of the body of Saint Christopher* (c.1453–7), which share a common setting and, behind the altar, the *Assumption of the Virgin* (c.1456–7), where he turned the narrow space to his

advantage by employing the illusionistic device of placing two of the apostles on the viewer's side of the fictive arch.

During the period of the Ovetari chapel Mantegna also executed other commissions which, like the frescoes, show his growing maturity as an artist. His earliest surviving painting, the *Saint Mark* (fig. 12; Frankfurt, Städelsches Kunstinstitut),[33] probably dates from around 1448–9, just at the period when he was beginning to work in the church of the Eremitani. As in Mantegna's early work in the tribune of the Ovetari chapel the influence of Pizzolo can be felt in the bulky figure of the saint and the strongly foreshortened book which projects beyond the fictive arch. The architectural framework and the decorative swag are elements familiar from Donatellesque Madonna reliefs, but Mantegna invests them with a heightened naturalism through the precise rendering of detail. The miniature-like quality of execution discernible in the Frankfurt painting became even more refined in later works, such as the *Adoration of the shepherds* in the Metropolitan Museum of Art[34] and the National Gallery's *Agony in the Garden*.[35] Two altarpieces survive from Mantegna's Paduan period, the first of which, the *Saint Luke* polyptych,[36] now in the Brera in Milan, was

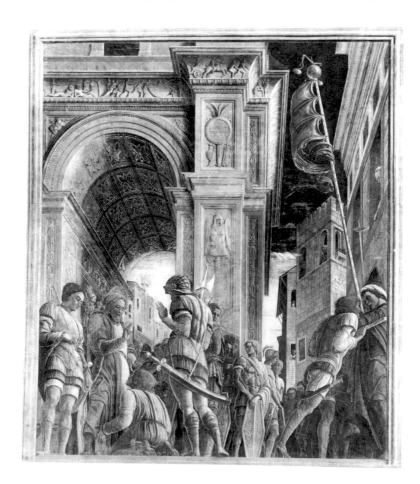

Fig. 11
Andrea Mantegna,
Saint James on his way to execution,
fresco in the church of the Eremitani, Ovetari chapel, Padua (destroyed in 1944).

executed for the church of Santa Giustina in 1453–4. The traditional format with a
gilded background and varying figure-scale was probably specified by the commis-
sion, and Mantegna may have been instructed to model his work on Vivarini and
d'Alemagna's altarpiece of 1448 painted for the Benedictine abbey of Praglia outside
Padua (now also in the Brera).

In the later of the two surviving altarpieces, which was painted for the church of
San Zeno in Verona (1456–9),[37] Mantegna had no such constraints and took as his
starting-point the format and some compositional elements of Donatello's Santo altar.
The central panel composition with the Virgin and Child isolated by columns and
flanked by four saints deployed in two diagonal lines on either side is close to the
likely arrangement of Donatello's *sacra conversazione* in the Santo. The illusion that
the figures are occupying real space is reinforced by the integration of the elaborate
classical frame with the painted architecture, which creates the impression that its
four fluted columns are the fourth side of an *all'antica* loggia inside which Mantegna's
figures are grouped. As in the lower register of the Ovetari chapel the low viewpoint

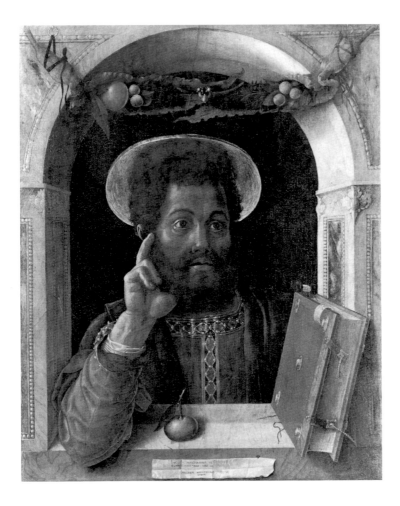

Fig. 12
Andrea Mantegna,
Saint Mark, casein (?)
and gold on canvas,
820 × 637 mm.
Frankfurt, Städelsches
Kunstinstitut

26

adopted by the artist enhances this impression, creating for the viewer in the nave of the church the illusion that the figures are occupying a real space above and beyond the altar. In order to heighten this sense of realism Mantegna even appears to have gone to the trouble of arranging for a window to be made in the choir so that the source of real light would conform to that in the painting.

Zoppo was, according to Vasari, a friend of Mantegna, their relationship based on their shared experience of Squarcione's studio. Zoppo's continuing admiration for Mantegna's work is shown in two of the British Museum drawings: the *verso* of the ex-Colville study from *c*.1455–7 (cat.no.8) and the copy from the 1470s of part of Mantegna's engraving of the *Entombment* (cat.no.23). But Zoppo's highly idiosyncratic treatment of Mantegna's fresco of *Saint James on his way to execution* in the former reveals his fundamentally different artistic temperament. In the drawing Zoppo adopts the form of the fresco but radically subverts its meaning – the solemn majesty of the saint's action in Mantegna's fresco is undermined in the drawing by the nudity of the figures and also by the unexplained violence of the child who is about to strike the kneeling supplicant. Mantegna's monumental triumphal arch, which symbolises the temporal power of the Roman Empire, becomes in Zoppo's study a platform for the strange and brutal play of children, and in the place of classicising detail he introduces a gigantic candelabrum of antique form supported by four children standing on a pedestal. The function of such a large-scale and highly finished drawing is mysterious; the moving image of the Dead Christ on the *recto* is like that of a devotional image, but on the *verso* the religious content is overwhelmed by the anecdotal detail introduced by the artist. The drawing conspires to show Zoppo's modernity in its references to Mantegna and Donatello, and at the same time displays his independence in the highly individual and almost whimsical manner with which he interprets their work. The style of the drawing with the forms modelled through tightly controlled parallel hatching is closely based on that of Mantegna. This way of drawing is perhaps the most enduring legacy of Zoppo's contact with Mantegna, since he remained true to it long after his paintings had evolved away from the hard-edged, sculptural style that is characteristic of the Paduan school, towards a softer, more Bellinesque manner.

Zoppo and Squarcione

It seems likely that Zoppo became a pupil of Squarcione (1394 or 1397–1468) soon after his arrival in the city. Squarcione's studio would have offered employment in a city where Zoppo probably had few local contacts and, more importantly, would have allowed him to study with the same master who had trained Mantegna. He must have proved himself an able assistant, as in May 1455 Squarcione adopted him as his son and heir. According to the adoption contract he had been with Squarcione for about two years. The nature of the agreement was that in return for his work Marco would receive living expenses and instruction, plus the promise of inheriting

Squarcione's estate on his death. The detailed description of the contents of the house refers to two studios, the larger of which contained 'reliefs, drawings and other things', while the smaller one is called the 'house with reliefs'. Squarcione was evidently a man of considerable means, and as a childless widower in his late fifties or early sixties Zoppo probably calculated that it was worth renouncing payment for the work he did in the studio in favour of the promise of eventually inheriting a far bigger prize on his master's death.

Unfortunately for Zoppo, shortly after the adoption Squarcione married a young widow who within a year or two bore him a son. Zoppo no longer had any chance of inheriting Squarcione's estate. He left the studio and by October 1455 was living in Venice. Two documents of that month record an agreement to arbitrate and annul the adoption. In relation to Zoppo's period in Squarcione's studio, these contradict the May adoption contract by stating that he had been with him only since April 1454. The arbiters rejected Squarcione's claim for his pupil to pay him living expenses and teaching fees, deciding instead that Zoppo should receive from him twenty gold ducats to repay the amount he had made from selling his pupil's paintings and drawings. This debt was settled by paintings, reliefs, medals and studio props which Zoppo took from Squarcione's studio in order that he could establish himself as an independent painter. The arbitration dissolved the adoption and marked the end of Zoppo's period in Padua.

The Louvre *Madonna and Child* (fig. 7) and the ex-Colville drawing show Zoppo's command of the Renaissance style, but how much this is directly attributable to Squarcione's teaching is questionable. Squarcione was in no doubt of his own importance as a teacher, declaring to a prospective pupil in 1465, 'it was I who made a man of Andrea Mantegna, who worked for me, and I will do the same for you'. Bernardo Scardeone's description of the artist in a history of his native Padua written in 1560 appears to support Squarcione's claim, describing him as 'the most singular and outstanding teacher of all time'. According to Scardeone, who based his account on a now lost autobiography by the artist, Squarcione had journeyed extensively through both Italy and Greece collecting material suitable for the training of young artists. On his return to Padua his school flourished, attracting by his own account one-hundred-and-thirty-seven pupils. It has been suggested that Squarcione offered his pupils both a practical and theoretical training in the arts, perhaps inspired by the enlightened educational methods first employed by Gasparino Barzizza in his humanist school established in Padua in 1407. If this assessment is correct Squarcione merited the status of father of painters (*pictorum pater*) accorded him by Scardeone, but the evidence to support this claim is not conclusive.

Squarcione was trained as a tailor and embroiderer, the profession of his maternal uncle who was responsible for his care after the death of his father. From documentary evidence he seems to have taken up painting at a relatively advanced age: his first recorded commission dates from 1426, when he was in his mid thirties. To judge from surviving documents he mainly worked on minor decorative commissions, such as the

decoration of the floor in front of Donatello's altar in the Santo (1449). His lack of employment is also alluded to by Scardeone, in his otherwise laudatory biography, where he describes Squarcione as a 'man of greatest judgement in art but, so it is said, of not much exercise in it'. Neither of his two surviving works is particularly accomplished. The earliest is the polyptych, painted between 1449 and 1452 and now in the Museo Civico, Padua,[38] which was commissioned by Leone de Lazzara for his family chapel in the church of the Carmine. In contrast with the polyptych by Giovanni d'Alemagna and Antonio Vivarini of 1447 painted for the church of San Francesco Grande in Padua (now in the National Gallery, Prague),[39] Squarcione's work shows no sign of influence from the Paduan works of Lippi and Uccello. His other work, the signed *Madonna and Child* (fig. 5), made about five years later and now in the Gemäldegalerie in Berlin, is, by contrast, in a much more modern manner. The great stylistic difference between the two works may be due to the fact that one, or conceivably both, were painted wholly or in part by Squarcione's shop. The Berlin painting is largely composed of motifs taken from Donatellesque reliefs. The clumsiness of the work is mainly due to the artist's unimaginative fidelity to these sculptural sources, as can be seen in the similarities between the profile view of the Virgin, whose head overlaps that of her son in the painting, and the composition of one of the Donatellesque reliefs included in the exhibition (cat. no. 3a).

The Berlin painting indicates a facile understanding of the principles of Renaissance art; and damning evidence of Squarcione's ignorance is supplied by the testimony of Maestro Agnolo di Maestro Silvestro, who complained in 1465 that the painter had duped him into believing that he could teach him perspective and 'all things pertaining to the painter's craft'. After a few months it became apparent to him that this was a deception. Forced to sue for breach of contract he claimed that Squarcione 'knows not how, either by his own work or by any words of explanation, to do the things he promised'. Some support for Maestro Agnolo's charge, at least with regard to Squarcione's shaky grasp of perspective, is provided by a contract of October 1467 relating to the apprenticeship of a certain Francesco who was the son of a painter. At the end of the notary's Latin contract Squarcione wrote in Italian a more specific account of what the boy would be taught. He describes how he will teach him to master proportional foreshortening both in the depiction of objects and the human figure according to a method, so he claims, of his own devising. The abstruseness of his description of his perspectival system strongly suggests that Squarcione had some general notion of current thinking on the subject but no real understanding of its practical application.[40]

The same contract provides a valuable insight into the importance of drawing in Squarcione's teaching practice. He promised to keep the boy 'with paper in his hand to provide him with a model, one after another, with various figures in lead white, and correct these models for him'. The copying of drawings was a traditional method of teaching artists – it is, for example, mentioned as a standard practice by Cennino Cennini in his treatise, *Il libro dell'arte*, written in Padua at the end of the fourteenth

century. Squarcione's collection of drawings is mentioned in a number of apprentice contracts and it evidently was one of the prime reasons why so many pupils were attracted to come to his shop. The first recorded instance of this is in a contract of apprenticeship of 1431 between Squarcione and a certain Michele di Bartolommeo, which states that he will be allowed to study the master's collection of drawings. Similarly, the nineteen-year-old Dario da Treviso, who had already matriculated as a painter, joined Squarcione in 1440 on the understanding that he would be paid an allowance on top of his living expenses, given instruction and allowed to see the drawings. A number of these are likely to have been drawings by Squarcione himself, contemporary sculpture, and paintings made on his travels, akin to the sketchbook – a *taccuino di viaggio* – compiled in Pisanello's studio in much the same period. Details of the drawings by other artists included in Squarcione's collection are scanty. He is known to have owned a drawing by Pizzolo because a copy was made of it in a contract of 1466 (fig. 22) to serve as a model for an altarpiece by Pietro Calzetta. And in 1474, after Squarcione's death, his son was still trying to retrieve eighteen drawings, including a cartoon of nudes by Pollaiuolo, which had been borrowed and never returned by Giorgio Schiavone. Squarcione's ownership of a drawing by Pollaiuolo, or more probably an impression of his engraving of the *Battle of the nude men*, suggests that he tried to keep his collection abreast with current fashions. It was presumably for the same reason that Squarcione, according to Vasari, also acquired paintings from Tuscany and Rome.

Of equal significance was Squarcione's collections of casts and reliefs which by 1455 were housed in two studios. Among these were probably casts of classical works, as Vasari states, but a substantial number would most likely have been from contemporary relief sculptures. The large quantity of gesso that Zoppo's father sent to him at Squarcione's studio, which is first mentioned in his adoption contract, was probably used to make copies of casts after antique works, and also Virgin and Child reliefs by Donatello and his followers, which would have been painted and then sold as devotional images. This activity is also mentioned in the same document when Zoppo promised that he and his heirs would not claim compensation for the works he had made and painted (*factis et pictis*) in Squarcione's studio. A heavily repainted cast in the Victoria and Albert Museum (fig. 4) which is based on a Donatello school plaquette (fig. 9) is an example of such a work. The relief was certainly known in Squarcione's studio because it was the model, as was mentioned earlier, for the painting of the *Virgin and Child* in the National Gallery (cat. no. 12) attributed to his pupil Giorgio Schiavone.

The effect of Zoppo's work as a sculptor of reliefs in Squarcione's studio can be felt in the emphatically plastic treatment of form in his early paintings. This is particularly marked in his only surviving Paduan painting, the Louvre *Madonna and Child* (fig. 7), which is signed on an illusionistically painted piece of paper attached to the front of the parapet 'Opera Del Zoppo de Squarcione'. This illusionistic device, which blurs the boundaries between the fictive and the real world, is a typical feature of Paduan

painting of the period[41] and was employed by Squarcione in the Berlin painting, by Mantegna in his *Saint Mark* (fig. 12) of the late 1440s, and by the latter again in the *Saint Euphemia* dated 1454, now in Naples.[42] The patron of the Louvre painting is established by the two identical coat-of-arms on either end of the parapet which have been identified as those of the Dardani, a Venetian family who had branches in Padua and Verona. In contrast to Squarcione's relief-like treatment of the Virgin, the figure in Zoppo's painting has a monumental solidity which is so exaggerated that she appears almost too massive to fit into the classical niche behind her. The main inspiration for the painting is the work of Donatello, as is evident both in the compositional form and the decorative elements. These are inspired by Donatello's reliefs of the Virgin and Child and the animated, music-making putti in the painting are closely based, even down to details of costume, on their counterparts in the twelve panels of the Santo altar.

Zoppo in Bologna and Venice

Nothing is known of Zoppo's activities after his departure from Padua by October 1455 until 1461, when he is known to have been in Bologna. His presence in the city is documented by a series of payments for decorative work in San Petronio dating from 1461–2. In the city he painted two works, both of which are still *in situ*: the *Crucifix*[43] painted for the church of San Giuseppe, and a polyptych for San Clemente, the chapel of the Collegio di Spagna.[44] The *Crucifix*, which is generally dated to the period 1460–3, is painted in a traditional Bolognese Gothic format consisting of a wooden panel in the shape of a cross with half-length figures of the Virgin and Saint John the Evangelist in quatrefoils at either end of the horizontal section. Zoppo invests the traditional form with a sculptural realism that derives from his experience of Paduan art, most notably in the expressive figure of Christ, which is modelled on Donatello's *Crucifix* in the Santo. The conservative form of the Collegio di Spagna polyptych of the same period was likewise probably dictated by the commission and the fact that it was designed for a Gothic setting. Yet despite the restraint of the format Zoppo's conception is essentially modern. The central panels show a *sacra conversazione* whose unified setting is established by the rectangular marble floor on which all the figures are placed, as in Mantegna's earlier *Saint Luke* polyptych. Zoppo transcends the flatness of the gold background by the accentuated plasticity of the figures, whose forms are broken up by the heavy folds of their drapery.

It is not known when Zoppo left Bologna but it must post-date September 1462, when he wrote a letter from the city to the Marchesa of Mantua in relation to a commission for two pairs of *cassoni*. One of the excuses he offers for not having completed the work on time is that he wants them to be worthy of comparison with the works of his friend Mantegna, who two years earlier had gone to serve the Gonzaga in Mantua. Zoppo is next recorded in Venice, where in 1468 he executed an altarpiece for the church of Santa Giustina. This has not survived but four panels

of half-length saints, including one in the National Gallery and another in the Ashmolean, are generally considered to be fragments from the work. In their soft colouring and delicate lighting effects, such as the highlights on the metallic curls of the saint's hair, they reveal Zoppo's response to Venetian painting, in particular the work of Giovanni Bellini. The combination of Paduan and Venetian elements in the Santa Giustina panels is also found in two devotional paintings from around the same period, the signed Washington *Madonna and Child*[45] painted for a member of the Corner family, and the National Gallery *Dead Christ with Saints John the Baptist and Jerome*.[46] Zoppo was also active during the 1460s as a painter of illuminations for Venetian patrons. In 1463 he illustrated a page for the *Epistolae ad Atticum* of Cicero, now in the Vatican Library, which was commissioned by the Venetian Marcantonio Morosini from the Paduan scribe Bartolomeo Sanvito (for an earlier

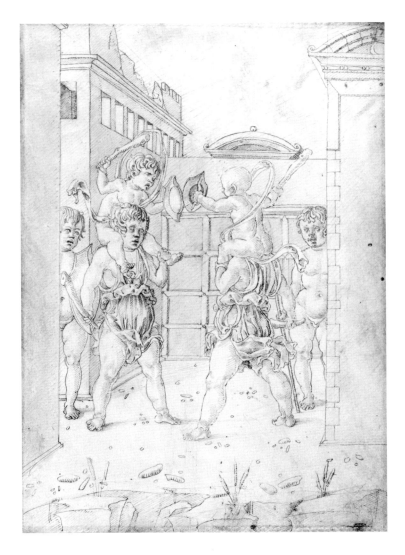

Fig. 13
Marco Zoppo,
Putti fighting,
pen and brown ink,
brown wash,
page 19 *recto* of the
Rosebery Album,
218 × 158 mm.
London, British
Museum

example of his work see cat. no. 1). A year or so later Zoppo provided three full-page miniatures for a manuscript by Sanvito (now in the Bibliothèque Nationale, Paris) of Virgil's works which, like the Cicero, may also have been commissioned by Morosini.

In 1471 Zoppo painted the high altarpiece for the recently constructed church of San Giovanni Battista in Pesaro. The building had been commissioned by the lord of Pesaro, Alessandro Sforza, and it is likely that Zoppo was his choice. When the church was pulled down in the sixteenth century the altarpiece was dismembered and only five panels survive. The original appearance of the work can be guessed at from Bellini's slightly later altarpiece of the *Coronation of the Virgin* painted for the church of San Francesco in Pesaro, which appears to have been closely based on Zoppo's work.[47] The main panel of Zoppo's altarpiece, now in Berlin,[48] is a *sacra conversazione*, and unusually for this early date the figures are shown in a pure

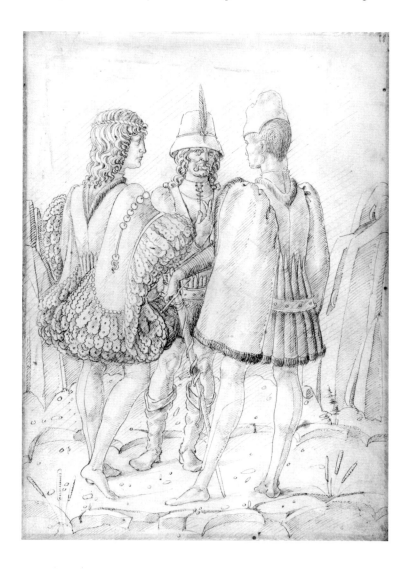

Fig. 14
Marco Zoppo,
Three figures in converse, pen and brown ink, brown and blue wash, page 7 *recto* of the Rosebery Album,
218 × 158 mm.
London, British Museum

landscape. From the period between 1471 until the artist's death in Venice seven years later there are no securely dated works. The few paintings which are generally believed to date from these years include the signed *Virgin and Child* (Altenburg, Staatliches Lindenau-Museum)[49] and the *Saint Sebastian* (Courtauld Institute Galleries).[50] The effect of Zoppo's long sojourn in Venice is reflected in their pellucid colouring and in the atmospheric landscape setting of the latter work.

Zoppo's Parchment Album

The largest surviving group of Zoppo drawings is contained in an album presented to the British Museum by the Earl of Rosebery in 1920. The volume consists of twenty-six leaves, of which twenty-four are drawn on both sides and two are blank on one side, making a total of fifty drawings. There is no reason to suppose that the album is not complete.[51] They are executed in pen and brown ink, some with broadly applied areas of brown wash, and in one example, the *Virgin and Child* (fig. 8), blue wash. The drawings are executed on vellum, the treated skin of sheep, calf or goat, which was more durable than paper but more expensive. Because the two sides of a piece of vellum differ slightly in tone and texture, the flesh-side being slightly smoother and lighter than the hair-side, it was normal practice in the arrangement of a vellum codex to match each opening. This alternation of flesh-side openings with hair-side openings is termed 'Gregory's Rule'. The album in its present state does not follow this rule but would do so if the drawings were put back according to the old, and possibly original, numbering in Arabic numerals inscribed in the upper right corner of most of the drawings. Combined with the stylistic unity of the drawings this shows that the studies were made specifically to be bound in an album. The present arrangement of the drawings probably dates from the end of the eighteenth or early nineteenth century when the vellum leaves were mounted on dull blue surfaced paper and adorned with a gilt border decoration around the edges of both the *recto* and *verso* of each drawing. At the same date the volume was bound in leather with gilt decoration and lettered on the spine 'Andrea Mantegna. Disegni'.

The drawings in the albums can be divided into two, with figurative compositions on the *rectos* and studies of bust-length figures on the *versos*. The drawings on the *rectos* can also be subdivided by subject. The largest number are the ten drawings of putti and children, all but one of which show them engaged in a physical activity, often of a violent nature (fig. 13). The next most sizeable group is made up of eight drawings of figures in conversation. Half of these figures are in fashionable courtly dress (fig. 14), while the remaining ones either wear Turkish or Greek costume, or are soldiers in fanciful classical armour (fig. 15). These two subject groups are sometimes combined – fashionably dressed figures appear in the backgrounds of two of the playing putti scenes and there are putti included in the two drawings of soldiers. Five of the remaining nine studies are of classical subjects, three of which, with varying degrees of certainty, have been identified: *The death of Seneca, The death of Pentheus*

(fig. 16) and the *Venus victrix*. The subjects of the other two drawings – *Two nude men wrestling* and *Two battling centaurs* – evoke antiquity but may not illustrate a particular classical episode. Two drawings that remain iconographically elusive depict men in Renaissance costume, one hacking down trees with his sword in the middle of a wood (fig. 17), and another a young horseman in a landscape with three nude women or nymphs in a pool (fig. 18). The remaining drawing is the Donatellesque *Virgin and Child* (fig. 9), the only religious subject in the album. The drawings on the *versos* form a much more coherent group.[52] With the exception of two drawings the *verso* studies of profile busts are all of men, the majority of them sporting fantastically decorated helmets (figs 19–21). If the drawings were in their original order all but two of the heads would face to the right in the first half of the album, while all of them would face to the left in the second half.

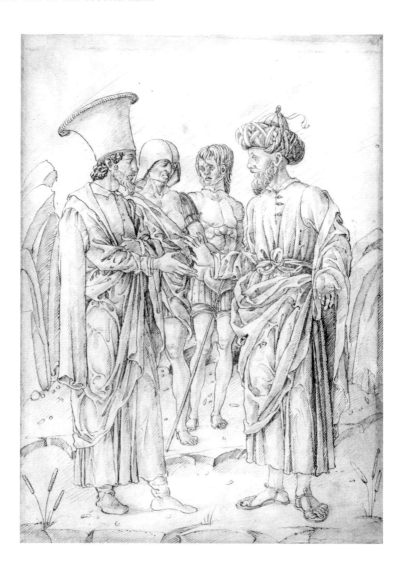

Fig. 15
Marco Zoppo,
*Two orientals with
two soldiers behind*,
pen and brown ink,
page 4 *recto* of the
Rosebery Album,
218 × 158 mm.
London, British
Museum

The function and meaning of the drawings have been much debated and have yet to be satisfactorily determined. The present exhibition includes two other drawing-books from the Museum's collection of about the same period, with which the Zoppo album can be compared in type and function – one by Jacopo Bellini (cat. no. 11) datable to the period 1440–60, and the *Florentine Picture Chronicle* (cat. no. 16), attributed to Baccio Baldini and his school which probably was drawn in the period 1470–5. Two drawing-books by Bellini survive, the one in the British Museum executed in leadpoint on ninety-nine leaves of paper, and one in the Louvre, which has drawings in a variety of media on ninety-three sheets of vellum. It is generally agreed that both were employed as model or pattern books in which Bellini's elaborate compositions were preserved so that they could be used for work-shop instruction and to serve as an inspiration for painted works. The London album

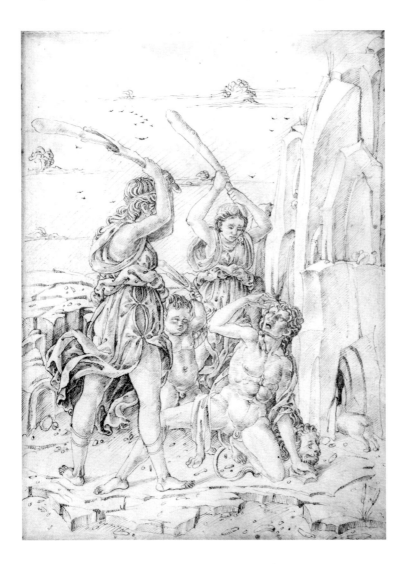

Fig. 16
Marco Zoppo,
Death of Pentheus,
pen and brown ink,
brown wash, page
21 *recto* of the
Rosebery Album,
218 × 158 mm.
London, British
Museum

offered the artist an opportunity to experiment with a wide range of compositional ideas which were then sometimes elaborated in the Louvre vellum album. Unlike Bellini's drawing-book, the highly finished drawings in pen and ink and wash in the *Florentine Picture Chronicle* are not the work of a single artist, as the quality of the draughtsmanship is too varied. They were intended to form a kind of 'world chronicle' divided into six ages beginning with the creation of the world. Selected figures from the Bible, mythology, legend and ancient history represent each of these ages. The chronicle was never completed and it ends with an unfinished drawing of Milon of Croton, who belongs in the Fourth Age. The elaborate nature of the compilation suggests that the *Chronicle* was intended as a luxury picture book which, because of the inscriptions identifying each figure, could be understood without the need of a further text.

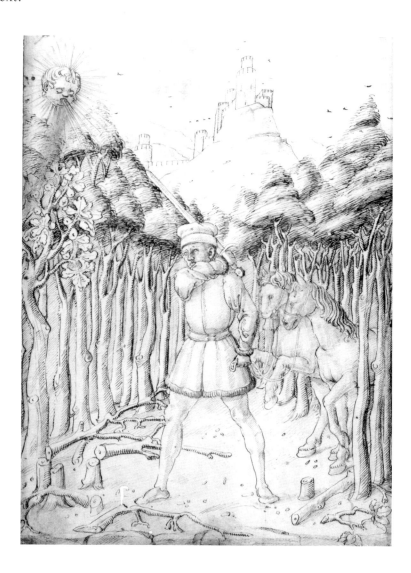

Fig. 17
Marco Zoppo,
A horseman in a wood, pen and brown ink,
page 26 *recto* of the Rosebery Album,
218 × 158 mm.
London, British Museum

The Zoppo drawing-book is closest in function to the *Chronicle* and it has sometimes even been suggested that the drawings illustrate a single text. But the sole religious image makes this unlikely. The highly finished quality of the drawings indicates that like the *Chronicle* Zoppo's album was a work of art in its own right, and that it was either specifically commissioned or made for sale as a luxury item. The homosexual imagery in some of the drawings, such as the drawing of a putti playing with bellows (cat. no. 15), or the phallic clubs held by the children in another study (fig. 13) makes it more likely that it was a private commission. Zoppo's witty and slightly irreverent references to antiquity, such as the enormous foot on a pedestal in the background of the drawing of the putti playing with the bellows, suggest that the patron might have belonged to the sophisticated literary and humanist circles of either Padua or Venice. The elusive meaning of some of the drawings suggests a

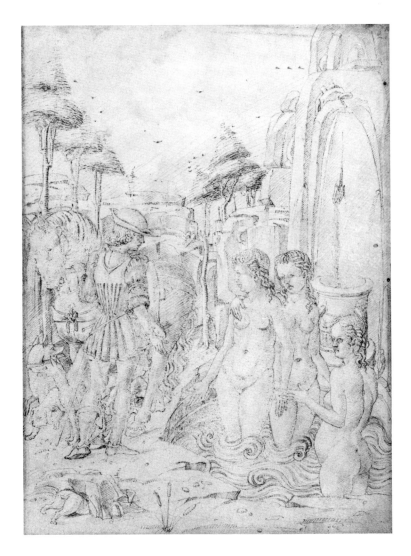

Fig. 18
Marco Zoppo,
A huntsman with three nymphs, pen and brown ink, page 22 *recto* of the Rosebery Album, 218 × 158 mm. London, British Museum

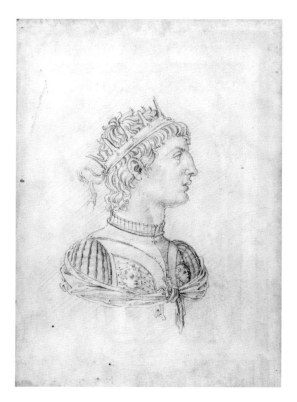

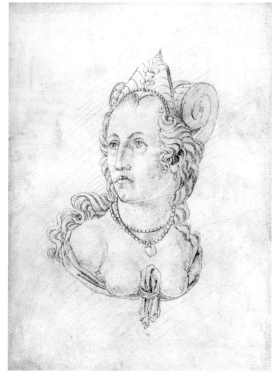

Above Fig. 19 Marco Zoppo, *Bust-length profile of a crowned man*, pen and brown ink, page 2 *verso* of the Rosebery Album, 218 × 158 mm. London, British Museum

Above, right Fig. 20 Marco Zoppo, *Bust-length study of a bare-breasted woman*, pen and brown ink, page 8 *verso* of the Rosebery Album, 218 × 158 mm. London, British Museum

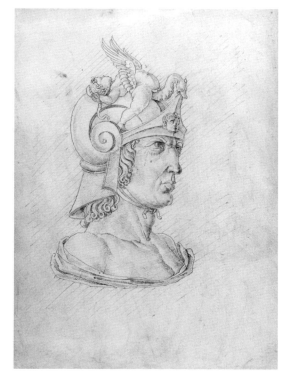

Right Fig. 21 Marco Zoppo, *Bust-length profile of a warrior*, pen and brown ink, page 10 *verso* of the Rosebery Album, 218 × 158 mm. London, British Museum

commission where the patron had a hand in providing some of the subject-matter, the significance of which may have been understood only by a small circle of friends. This theory would explain the inclusion of drawings whose subject-matter is found in literature, such as the horseman with the nymphs.[53] But many of the drawings do not seem to illustrate a literary source and appear to be designed to show off Zoppo's powers of invention rather than the erudition of a putative patron . The extraordinary series of battling putti, for example, display Zoppo's ingenuity in treating a theme for which, from the evidence of the ex-Colville drawing, he had a special fondness. Two other examples of finished studies on vellum by Zoppo, including one in the present exhibition (cat. no. 17), suggest that the drawing-book is not an isolated case of the artist making finished drawings for sale.[54]

Like so many painters of the period, Zoppo's reputation has suffered from the dispersal and partial destruction of a number of his key works. The two most important commissions of his maturity, the altarpieces in Santa Giustina in Venice and in San Giovanni Battista in Pesaro, have both been dismantled, and only in the case of the latter has a sufficient number of the panels survived to give some impression of its original state. Many of his drawings must also have perished, because aside from the Rosebery album Lilian Armstrong, in her exemplary monograph on the artist, lists less than twenty, not one of them related to his paintings. Zoppo's surviving drawings are of a consistently high quality and it is arguably through his drawn work rather than his paintings that his highly original, and often peculiar, imagination is most clearly expressed. These qualities are most evident in the Rosebery album folios and the drawings from the Madonna sketchbook which, despite the limitations of the subject-matter, never become repetitive or dull. The acquisition of the ex-Colville drawing, a touchstone of Zoppo's early Paduan manner, completes the British Museum's holdings of his work. It shows that Zoppo's drawings are worthy of comparison with those by his better known contemporaries in northern Italy.

1 Illustrated in Vigi (ed.), 1993, p. 149

2 *ibid.*, p. 150

3 *ibid.*, p. 153

4 *ibid.*, p. 154

5 *ibid.*, pp. 155–62

6 *ibid.*, pp. 170–3

7 *ibid.*, pp. 175–8

8 *ibid.*, pp. 179–84

9 For a survey of Bolognese paintings of the first half of the fifteenth century see R. Grandi in Zeri (ed.), 1987, I, pp. 222–33

10 Pope-Hennessy, 1972, pls 90–5

11 Illustrated in Zeri (ed.), I, p. 240, fig. 322

12 Humfrey, 1993 (I), pp. 163–4, fig. 144

13 For Mantegna's links with Paduan humanists see D. Chambers, J. Martineau and R. Signorini in Exh. London and New York, 1992, pp. 8–15 and Lightbown, 1986, pp. 24–5

14 Exh. London and New York, 1992, pp. 17–18

15 Vigi (ed.), 1993, p. 123. For Zoppo's activity as a manuscript painter see G. Mariani Canova, 'Marco Zoppo e la miniatura' in Vigi (ed.), 1993, pp. 121–35

16 Illustrated in Vigi (ed.), 1993, p. 201

17 *ibid.*, pp. 202–7

18 A translation of this is given in Welch, 1997, pp. 104–5

19 For a discussion of Lippi in Padua and his influence, see De Marchi, 1996, pp. 5–23

20 Janson, 1963, pp. 147–87, figs 68–88

21 Lightbown, 1986, pp. 406–8, cat. no. 9, pls 36–42

22 Humfrey, 1993 (I), pp. 168–70, fig. 156

23 *ibid.*, fig. 155

24 For an illustration of the altarpiece before the destruction of the chapel see Lightbown, 1986, pl. 1

25 For this and other borrowings from Donatello see Levine Dunkelman, 1980, pp. 226–35

26 For an analysis of this compositional type see Armstrong, 1976, pp. 15–28

27 The attribution is wrongly doubted by Lightbown, see Exh. London and New York, 1992, cat. no. 12

28 For this and other borrowings by Schiavone see Kokole, 1990, pp. 50–6

29 Lightbown, 1986, p. 424, cat. no. 27, pl. 100

30 One from the Metropolitan Museum of Art, New York is illustrated in Exh. London and New York, 1992, p. 153, fig. 71

31 For Mantegna and Squarcione see Lightbown, 1986, pp. 15–29 and K. Christiansen in Exh. London and New York, 1992, pp. 94–110

32 For Mantegna's work in the Ovetari chapel see Lightbown, 1986, pp. 387–400, cat. no. 1, pls 1–28

33 The autograph status of this work, doubted by Lightbown, is convincingly argued in Exh. London and New York, 1992, p. 119, cat. no. 5

34 Lightbown, 1986, pp. 403–4, cat. no. 5, pl. 33

35 *ibid.*, p. 404, cat. no. 6, colour pl. II

36 *ibid.*, p. 401, cat. no. 3, colour pl. I

37 The altarpiece is still *in situ* with copies of the three predella panels which are divided between the Louvre and the Musée des Beaux-Arts, Tours. Lightbown, 1986, pp. 406–8, cat. no. 9, pls 36–42

38 See Lightbown, 1986, pl. 248

39 Humfrey, 1993 (I), pp. 163–4, fig. 145

40 It has been recently suggested that he might have known of Piero della Francesca's work in this field, see Bambach Cappel, 1994, pp. 40–1. A translation of the contract is given in Gilbert, 1980, pp. 33–4

41 For a discussion of this illusionistic device see Fortini Brown, 1996, p. 191

42 Lightbown, 1986, pp. 402–3, cat. no. 4, pl. 31

43 Illustrated in Vigi (ed.), 1993, p. 154

44 *ibid.*, p. 155–62

45 *ibid.*, p. 168

46 *ibid.*, p. 163

47 For an analysis of the two works see P. Humfrey, 'La Pala di Pesaro' in Vigi (ed.), pp. 71–8

48 Illustrated in Vigi (ed.), 1993, p. 175

49 *ibid.*, p. 185

50 *ibid.*, p. 186

51 Elen suggests that four leaves are missing as he misreads the '6' on page 33 recto as '30'. This folio cannot have been at the end of the album as the worm-holes are consistent with those pages at the beginning of the book. The pattern of worm-holes in the album, which correspond to insects eating their way through either the front or the back of the work, differ markedly according to the position of the folio.

52 Lilian Armstrong has suggested that some of these may have been preparatory for woodcuts for book illustrations, see Armstrong, 1993, pp. 79–95

53 The subject of men encountering women or nymphs bathing was frequently treated in late medieval and Renaissance pastoral poetry and songs, see Holberton, 1989, pp. 174ff.

54 The other vellum drawing, curiously ignored in the literature on the artist, is in Berlin, see Exh. Berlin and Saarbrücken, 1995–6, pp. 269–70

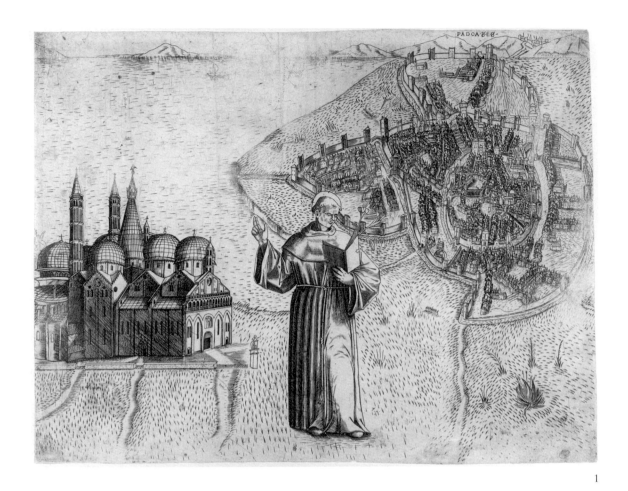

1

1 Paduan (?) School, *c.*1500–20

Saint Anthony with the basilica of Sant'Antonio and a bird's-eye view of the city

Woodcut; inscribed: *PADOA B.E.B.* 235 × 306 mm

Literature: Hind, 1938–48, I, p. 268, no. 55, IV, pl. 440

British Museum (1860-6-9-55)

In the centre of this single block woodcut there is an image of Saint Anthony of Padua (1195–1231), the great Franciscan preacher and miracle-worker who arrived in the city in the 1220s. His tomb in the basilica of Sant'Antonio, also known as the Santo, is one of the great pilgrimage sites in Italy and for centuries has contributed to the wealth of the city. The Santo, shown on the left of the print, was begun in the 1230s and was more or less completed by the mid fourteenth century. The church was at the centre of much of the artistic life in the city, and a number of the artists in the present exhibition are known to have worked there. Donatello completed two projects in the basilica during his ten-year stay in Padua (1443–53): a bronze life-size crucifix and the high altar. His other major work in the city, the equestrian sculpture of the mercenary Erasmo da Narni, known as Gattamelata, was executed in the piazza outside (the latter monument is shown in a schematic fashion in the print). Squarcione, the master of Mantegna and Zoppo, had his house and studio close to the basilica and he executed a number of works there (none of which has survived). His rival Jacopo Bellini,

Mantegna's father-in-law, painted an altarpiece for the widow of Gattamelata for the family's funerary chapel in the church. On the right of the print there is a bird's-eye view of the city, showing the medieval outer walls.

2 *Oratio gratulatoria*, Bernardo Bembo

Folio 1: script attributed to Bartolomeo Sanvito; illumination attributed to Franco dei Russi

Bodycolour, on vellum. 105 × 162 mm

Provenance: Acquired from Payne, 1844

Exhibited: London and New York, 1994–5, no. 26

Literature: G.M. Canova in Exh. London and New York, 1994–5, pp. 83–4, no. 26 (with previous literature)

The British Library, Additional MS 14787

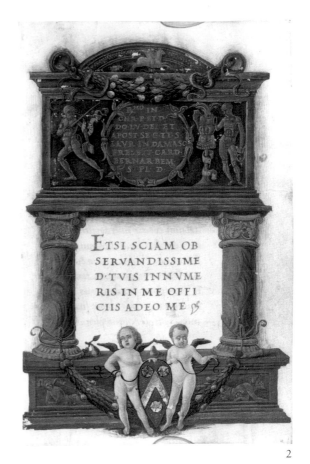

2

The *Oratio* was written in 1462 by the Venetian Bernardo Bembo (1433–1519) to honour the election in that year of Doge Cristoforo Moro. The encomium was addressed to the new Doge by Bembo (who later became one of Venice's leading diplomats) on behalf of the law faculty of the University of Padua where he was a student. This manuscript probably dates from the following year because Bembo states that it had been composed some time earlier, and a *terminus ante quem* is provided by the death in 1465 of Cardinal Ludovico Trevisan, to whom this copy is dedicated. The Cardinal's arms of the half-wheel (*mezzaruota*), the family name of his Paduan mother, are shown hanging around the neck of Pegasus, a symbol of good repute, in the tympanum of the architectural structure whose form is based on Roman sarcophagi. Trevisan was educated in Padua and maintained close links with the city, acquiring in 1451 a site in the Arena to build a family palace. He was one of the most prominent antiquarian collectors of the period and also took an interest in contemporary painting. Bernardino Scardeone (*c.*1478–1574), the author of a history of his native Padua, lists the Cardinal among Squarcione's admirers. He also sat for a portrait by Mantegna in

the late 1450s, now in Berlin (see Lightbown, 1986, cat. no. 11, pl. 46).

The scribe of the work is the outstanding Paduan calligrapher Bartolomeo Sanvito (1435–1518), who later collaborated with Zoppo on two manuscripts: the *Epistolae ad Atticum* by Cicero, now in the Vatican, and the works of Virgil in the Bibliothèque Nationale in Paris. The illuminations by Franco dei Russi (active *c.*1453–82), who earlier worked in Ferrara on the Bible of Borso d'Este, are typical of the sophisticated classical style adopted by Paduan illuminators of the period. The decorative elements in the present illumination – such as the pair of putti flanking Bembo's arms, the fruit-laden swags and the pears on the ledge behind the armorial shield – are inspired by motifs found in reliefs by Donatello, as well as by paintings by Mantegna, Zoppo and other Squarcionesque artists.

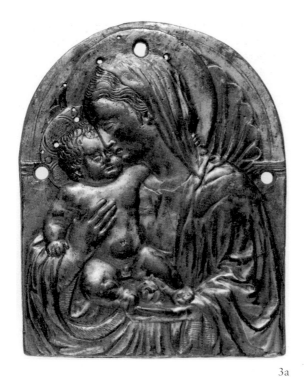

suggested that it may be the work of Michelozzo di Bartolommeo (1396–1472), who collaborated with Donatello on several important projects. A terracotta relief usually ascribed to Michelozzo in the Bargello in Florence shows the Virgin in profile against a very similar shell-niche background.

Another example of the plaquette in the British Museum (MLA 1915–12–16–325) is mounted as a pax bearing the arms of Marino Tomacelli, Bishop of Cassano 1485–91, and is dated 1486. However, the dependence on works such as the *Pazzi Madonna* make it probable that the design originated earlier in the fifteenth century. J.W.

3a Follower of Donatello, probably Florentine, *c.*1430–50

The Virgin and Child before a niche

Gilt bronze plaquette. 98 × 78 mm

Provenance: Given by C. D. E. Fortnum

Literature: Molinier, 1886, no. 372; Bange, 1922, no. 292; Bell, 1930, no. 38; Pope-Hennessy, 1965, no. 57; Pope-Hennessy, 1993, no. 253, fig. 255; Toderi, 1996, no. 101

Ashmolean Museum (WA 1888.CDEF.B653)

The close connection between this small plaquette and larger reliefs designed by Donatello and executed in marble or terracotta has long been acknowledged. The sharply defined profile of the Virgin and the setting of the figures within an architectural space can both be compared to the *Pazzi Madonna* in Berlin of *c.*1428–30. Although it has been suggested that the plaquette may record a lost relief by Donatello, the design was probably invented by an associate or follower of Donatello in Florence or Padua. Pope-Hennessy tentatively

3b Paduan School, perhaps after Donatello, *c.*1440–50

The Virgin and Child between two candelabra

Bronze plaquette. 97 × 85 mm

Provenance: Given by C. D. E. Fortnum

Literature: Molinier, 1886, no. 367; Bange, 1922, no. 345; Bell, 1930, no. 40; Pope-Hennessy, 1965, no. 59; Toderi, 1996, no. 100

Ashmolean Museum (WA 1888.CDEF.B610)

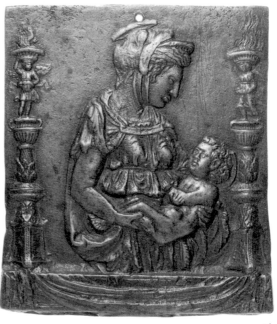

3c

One of the most beautiful of the plaquette designs associated with Donatello and, to judge from the number of surviving versions, also one of the most popular. Donatello made a number of reliefs of the Virgin and Child during the decade he spent in Padua (1443–53). This plaquette has been considered by most scholars to be Paduan in origin and it has been suggested that it possibly records a lost relief by Donatello himself. The figure of the Virgin with her complex drapery can be related to larger reliefs of the Madonna and Child made by Donatello during the 1440s and 1450s. A marble relief of this subject in the Victoria and Albert Museum, ascribed to the so-called 'Piccolomini Master' but thought to derive from a lost original by Donatello, depicts similar candelabra with flaming braziers. J.W.

3c Probably Paduan School, *c.*1450–80

The Virgin and Child with sixteen angels

Bronze plaquette. 93.5 × 73 mm

Provenance: Given by C. D. E. Fortnum

Literature: Molinier, 1886, no. 381; Bange, 1922, no. 586; Bell, 1930, no. 46; Pope-Hennessy, 1965, no. 303; Toderi, 1996, nos 238–9

Ashmolean Museum (WA 1888.CDEF.B658)

Another plaquette which survives in large numbers. Most scholars have regarded it as Paduan, although Siena and Ferrara have also been suggested, the latter on the basis of comparison with the *Madonna and Child* from the Roverella altarpiece by Tura in the National Gallery. A Paduan or possibly Venetian origin seems more probable. The elaborate architectural setting and crowded composition can be related to Mantegna's San Zeno altarpiece. Gambolling putti appear in the work of other followers of Squarcione, notably Schiavone and Zoppo, as well as in Venetian manuscript illustrations. Parallels for the twisting figure of the Virgin can be found in contemporary Paduan painting, for example Schiavone's *Virgin and Child* in Turin. The plaquette was probably designed during the third quarter of the fifteenth century. J.W.

3d

3d Ascribed to Moderno (Galeazzo Mondella), late fifteenth century

The Dead Christ supported by the Virgin and Saint John

Bronze plaquette. 82 × 57.5 mm

Provenance: Given by C. D. E. Fortnum

Literature: Molinier, 1886, no. 386; Bange, 1922, no. 525; Bell, 1930, no. 48; Pope-Hennessy, 1965, no. 181; Lewis, 1989, no. 12

Ashmolean Museum (WA 1888.CDEF.B603)

Although it has sometimes been thought to be the work of a follower, this plaquette is likely to be an autograph work by the Veronese goldsmith and medallist Galeazzo Mondella (1467–1528), more generally known as 'Moderno' from the signature he used on some of his plaquettes. Moderno was one of the most versatile and accomplished makers of plaquettes in Renaissance Italy. He worked for a time in Mantua, where he presumably chose his artistic sobriquet by way of contrast with the great Mantuan bronzist 'Antico' (*c.*1460–1528). The half-length *Pietà* composition, with Christ supported either by the Virgin and Saint John or by grieving angels, was especially popular in the Veneto. Donatello made a relief of the subject in bronze for the Santo in Padua around 1450 (fig. 2), whilst from the 1460s onwards Giovanni Bellini created a number of moving paintings on this theme. Moderno's composition, probably created around 1490, is closely related to Bellini's large *Pietà* in the Doge's Palace in Venice and may even derive from it. In the plaquette the scene of pagan sacrifice in the altar frieze is explicitly compared to Christ's own sacrifice, the sarcophagus itself in effect serving as an altar. J.W.

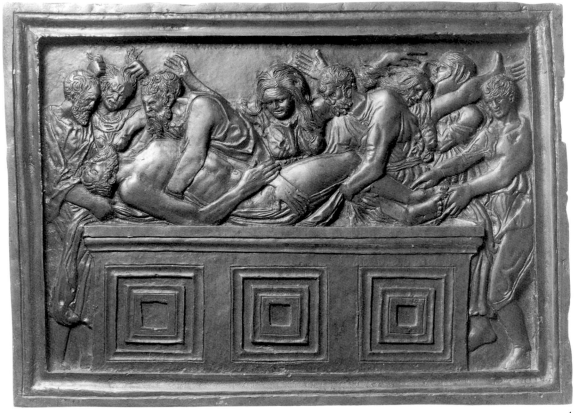

4

4 Paduan School, after Donatello, c.1450-60

The Entombment

Bronze plaquette. 157 × 217 mm

Provenance: Bequeathed by C. D. E. Fortnum

Literature: Lloyd, 1989, pp. 207–26

Ashmolean Museum (WA 1899.CDEF.B615)

Unlike the other plaquettes exhibited here, which survive in multiple versions, this relief depicting the body of Christ being laid in the Tomb is unique. It is, in fact, a miniature version of the large limestone relief commissioned from Donatello in 1449 by the authorities of the Santo in Padua and today set into the back of the high altar of the Santo. The bronze follows the larger relief closely, the main differences lying in the decorative panels of the sarcophagus and in the background, which is patterned in mosaic in the limestone relief. Although on a much smaller scale, the bronze version captures well the monumental grief-laden qualities of Donatello's composition. It has on occasion been suggested that it might be a model for the limestone relief and thus by Donatello himself, but this seems unlikely. Some passages, notably the frenzied female figures in the background, are of very high quality. But other parts, for example the man on the right holding Christ's feet, are disappointingly weak. It may instead have been made by one of Donatello's Paduan assistants around the middle of the fifteenth century, or a litttle later. It has, for example, recently been suggested that the relief might be a very early work by the greatest bronzist of the early Renaissance, Andrea Briosco, known as 'Riccio' (1470–1532). J.W.

5 Studio of Francesco Squarcione (1394 or 1397–1468)

Saint Christopher in Samos

Pen and brown ink, brown wash, on pale brown paper. Some of the figures are tinted in yellow, dull red, or pale grey-blue, the sky and the buildings are faintly washed in brown or red. 128 × 128 mm

Provenance: J. C. Robinson; J. Malcolm

Literature: Robinson, 1876, p. 127, no. 355; Tietze, 1942, pp. 54–60, fig. 1; Tietze and Tietze-Conrat, 1944, p. 181, under no. A750; Popham and Pouncey, 1950, pp. 156–7, no. 253, pl. CCXIV; Ragghianti, 1962, p. 25, fig. 15; Schmitt, 1974, p. 206, pp. 212–13, footnote 10; N. Turner in Exh. London, 1994, pp. 59–60, under no. 65; Ames-Lewis, 1990, p. 662; de Marchi, 1996, p. 23, footnote 64

British Museum (1895-9-15-802)

Tietze (1942) was the first to suggest that both this and the following drawing were by the same hand, and that both drawings were similar in style to the sketch attached to the contract of 17 October 1466 between the painter Pietro Calzetta and Bernardo de Lazzara (fig. 22) relating to an altarpiece to be painted in the Santo. The work was to correspond with a drawing in the possession of Squarcione executed by his former pupil Niccolò Pizzolo. The drawing was copied by the scribe of the contract, Bartolomeo Sanvito (see cat. no. 2). His responsibility for the copy is established by the fact that the colour of the ink of the inscription accords with that of the drawing, even in their changes of tonality. If, as seems likely, Sanvito's copy is an accurate one, it is probable that the similarities in the sketchy drawing style between the British Museum drawings and Pizzolo's lost original reflect a common training of the artists in Squarcione's workshop.

As Tietze points out, the two British Museum studies may be connected with the frescoes of scenes from the life of Saint Christopher on the right-hand wall of the Ovetari chapel which, like the drawings, are roughly square in format. Neither of the two episodes in the drawings was treated individually, as both stories appear in the representation of the *Sermon of Saint Christopher*

by Ansuino da Forlì. If the drawings are related to the Ovetari chapel they must represent a failed attempt by a pupil of Squarcione – perhaps, as Tietze and de Marchi have suggested, by Pizzolo, or conceivably even by the master himself – to obtain a share of the commission.

The most likely date for this and the following drawing would be in 1450, immediately after the death of Giovanni d'Alemagna who, with his brother-in-law Antonio Vivarini, had been commissioned to paint the main vault and the right-hand wall. By 1450 the two artists had only completed part of the vault and Ovetari's executors were constrained to find other artists to fulfil the commission. Ragghianti's suggestion that the drawings are by the young Mantegna is unconvincing, as is the tentative attribution to Pizzolo, because it seems implausible that either artist, after their close study of Donatello's Santo reliefs, would have composed scenes with spatial settings so reminiscent of Paduan late Gothic painting. The question

Fig. 22 Bartolomeo Sanvito after Niccolò Pizzolo, contract drawing for the Lazzara altarpiece, 1466, pen and brown ink, 300 × 429 mm (J. Paul Getty Museum, Malibu)

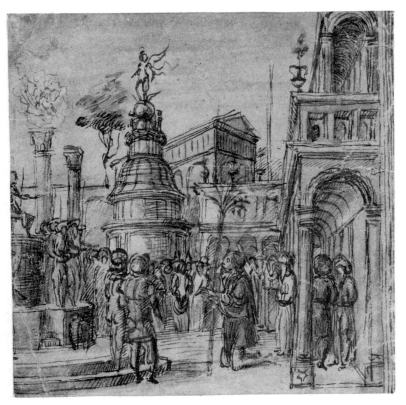

5

of attribution will probably never be resolved, but the interest of the drawings is, as Tietze rightly noted, that they provide an insight into the style of Squarcione's shop. They also reveal how little Mantegna's forceful early drawing style (see cat. no. 7) owed to his training with Squarcione.

According to legend Saint Christopher was of gigantic stature. On his arrival in the city of Samos in Lycia he prayed to God that his staff might bloom and that the people might thereby be converted. His wish was granted and, following Jacopo de Voragine's account of the saint's life in the *Golden Legend*, eight thousand men became Christians.

6 Studio of Francesco Squarcione (1394 or 1397–1468)

The arrest of Saint Christopher

Pen and brown ink, brown wash, on pale brown paper; inscribed: *An Canal di.* 133 × 133 mm

Provenance: W. H. Schab; H. M. Calmann

Exhibited: London, 1994, no. 65

Literature: Tietze, 1942, pp. 54–60, fig. 2; Tietze and Tietze-Conrat, 1944, p. 181, no. A750; Popham and Pouncey, 1950, p. 156, under no. 253; Ragghianti, 1962, p. 25; Schmitt, 1974, pp. 206, 212–13, footnote 10; Ames-Lewis, 1990, p. 662; N. Turner in Exh. London, 1994, pp. 59–60, no. 65; de Marchi, 1996, p. 23, footnote 64

British Museum (1952-5-10-7)

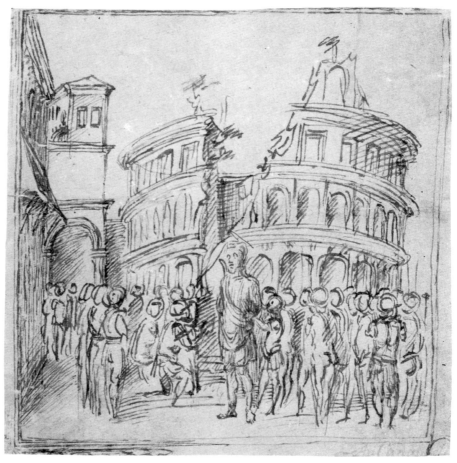

6

In the *Golden Legend* the arrest of Saint Christopher immediately follows the episode of the blooming staff represented in the previous drawing. Two hundred men were sent by King Dagnus to arrest the Saint in Samos. Despite his size he did not resist capture and his courage and faith moved the soldiers to convert to Christianity.

7 Andrea Mantegna (*c.*1431–1506)

Saint James on his way to execution

Pen and brown ink, on pale pink prepared paper, with traces of black chalk; inscribed in pencil at upper-left corner: *Mantegna*. 155 × 234 mm

Provenance: Earl Spencer (L. 1530), probably his sale, T. Philipe, 10 June 1811, lot 39 ('Gentile Bellini – a scripture or saint subject of many figures – *free pen*'), £1. 2s., bt. Ottley; W. Young Ottley, his sale, T. Philipe, 13 June 1814, lot 777 ('a saint-subject of many figures – *free pen, an early performance, painted in the Church of the Eremitani, at Padua*'), £2. 15s.; T. Lawrence (L. 2445); J. Malcolm;

A. E. Gathorne-Hardy. Accepted by H.M. Treasury in lieu of Estate Duty, with a contribution from the bequest of Richard William Tuck

Exhibited: London, 1930, no. 152; London and New York, 1992, no. 11

Literature: Kristeller, 1901, pp. 101–2; Lightbown, 1986, p. 481, no. 176; D. Ekserdjian in Exh. London and New York, 1992, pp. 135–8, no. 11 (with further literature)

British Museum (1976-6-16-1)

This is a study for Mantegna's fresco formerly in the Ovetari chapel in the church of the Eremitani in Padua (figs 10 and 11). The fresco at the left of the lower tier on the left-hand wall was originally assigned to Niccolò Pizzolo, so the drawing must date from after his murder in 1453. The fresco was completed by January 1457. The many differences between this and the finished work, and the revisions to the outlines of the figures (most clearly in the position of the saint's head), indicate that this drawing dates from the beginning of the preparatory process. The basic composition of the figures

in the finished fresco is close to that established in the drawing, with the prominent figure of the soldier in the centre acting as the link between the two halves of the composition. In the drawing the most heavily worked areas are the central soldier and the figure of the saint. In the study the saint bends forward to bless the kneeling figure of Josiah, while in the fresco he is shown more frontally and in an almost upright pose. The figures on the right of the composition, in contrast, are drawn in a more summary fashion and, perhaps following Leon Battista Alberti's advice in his *Della Pittura*, are shown in the nude. The saint and the soldier in the centre also appear to have been drawn unclothed at first, their drapery only added after their poses had been established (a sequence that was to become standard practice in Renaissance workshops). The architectural background is sketched in with the barest of details, but to judge from the curving form of the structure visible behind the figure of the saint, Mantegna had not yet envisaged the triumphal arch which towers above the scene in the finished work.

The freedom in the handling is suggestive of an artist rapidly thinking out compositional and figural ideas. Except for the four protagonists on the left, the figures in the drawing are mainly delineated by outline, with only minimal internal modelling. Parallel hatching is used to model the figures on the left, most notably in the curving lines on the upper leg of the central soldier, but in the rest of the drawing it is employed as a means of shading, broadly indicating the fall of light on the right-hand side of the composition. The manner of handling the pen is far more dynamic and vital than that of the two Squarcione studio drawings (cat. nos 5 and 6), and it is tempting to attribute this to Mantegna's contact with Donatello. Unfortunately, there are no securely attributed drawings by the sculptor, but a rapid pen study of the *Massacre of the Innocents* in Rennes (see Exh. Rennes, 1990, pp. 14–15, no. 2), traditionally attributed to Donatello, may provide a clue to the formation of Mantegna's style.

In the centre of the present drawing there is an area of black chalk which on close inspection can be read as a study of a bust-length male figure in a roundel. This cannot be related to any painted work, but it may conceivably have been an unrealised idea for an *all'antica* relief in the background of the fresco.

The drawing was first published as the work of Mantegna by Kristeller in 1901. At the time it was in the Gathorne-Hardy collection, where it had previously been attributed to Donatello. A hitherto overlooked detail of the drawing's provenance reveals that the attribution to Mantegna had been made ninety years earlier by William Young Ottley (1771–1836), one of the foremost connoisseurs of the nineteenth century. Ottley, who for a short period at the end of his life was Keeper of the Prints and Drawings Department of the British Museum, appears to have bought it at the sale of Earl Spencer where it had been mistakenly attributed to Gentile Bellini. Ottley spent almost nine years in Italy (1791–9), where he travelled widely, building up his collection of paintings, drawings and prints, and it is likely that he had first-hand knowledge of Mantegna's frescoes in Padua. (For Ottley's activities as a dealer and collector in Italy see Ingamells, 1997, pp. 728–9.)

8 Marco Zoppo (1432/3–78)

The Dead Christ supported by angels (recto); Saint James on his way to execution (verso)

Brush and brown wash, pen and brown ink, faded red wash on the swag (*recto*); pen and brown ink, brown wash (*verso*), on vellum; inscribed on the neck of a vase on the *verso*: I U S, and in a sixteenth-century (?) hand on the lower-left margin of the *recto*: *Michelangelo*. 350 × 280 mm

Provenance: Duke of Anhalt-Dessau; D. Giese, London, 1937; P. & D. Colnaghi, March 1937, from whom bought by Lieutenant Colonel Norman Colville MC for £1,250; acquired from the Colville family by a private treaty sale with a contribution from the Heritage Lottery Fund and the National Art Collections Fund

Exhibitions: London, 1953, no. 120; London, 1997, no number

Literature: K. T. Parker and J. Byam Shaw in Exh. London, 1953, no. 120; Scharf, 1953, p. 352;

Ruhmer, 1966, pp. 29–30, 60–1, figs 7–10;
Armstrong, 1976, pp. 56–72, 392, no. D.1, figs 35–6;
De Nicolò Salmazo, 1990, pp. 523–4, *recto*
illustrated fig. 605; C. Schmidt in Vigi (ed.), 1993,
p. 140, *recto* illustrated p. 138

British Museum (1995-5-6-7)

The attribution to Zoppo for the drawing was first
advanced by K. T. Parker and J. Byam Shaw in their
catalogue entry in the Royal Academy exhibition of
1953. Alfred Scharf in his review of the exhibition
doubted the attribution, but all later authorities
have accepted the work as Zoppo's earliest sur-
viving drawing. It probably dates from 1455–60,
the period following Zoppo's break with
Squarcione. This dating is supported by the simi-
larities in composition and type – particularly
noticeable in the chubby putti – between Zoppo's
Louvre painting of the *Virgin and Child* of
c.1455 (fig. 7) and the *recto* of the drawing. The
drawing almost certainly dates from a few years
after the Louvre painting, as the *verso* is based on
Mantegna's fresco of *Saint James on his way to
execution* (fig. 11) in the Ovetari chapel, which was
completed by 1457.

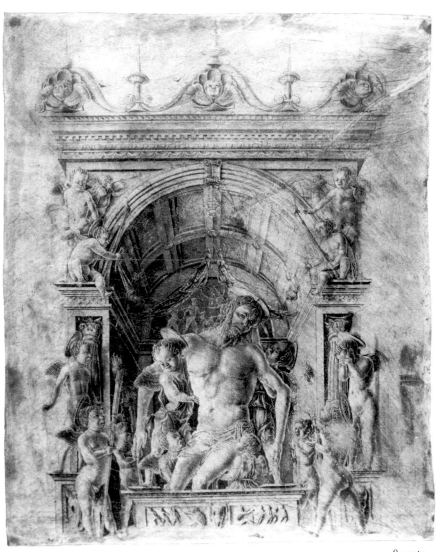

8 *recto*

The function of this highly finished work drawn on vellum is unknown. The *recto* drawing with its moving depiction of the Dead Christ, his face marked by the suffering he has endured, has the character of a private devotional work. The subject of the *verso* is ostensibly a sacred one, but the nudity of the figures and the animated play of the putti in the background focuses attention away from the religious narrative. The two drawings also differ in their technique. The *recto* is drawn largely with the brush, the pen confined to defining the outline of the architectural elements and to some

minor additions to the faces of the putti. Zoppo uses wash in the modelling of Christ's bronze-like torso with impressive control, and he depicts the folds of the putti's draperies with great intricacy. The *verso*, by contrast, is a virtuoso display of the pen in the manner of Mantegna, with sharply defined outlines and modelling based on tightly regulated hatching and the sparing use of wash.

Together, the two sides offer a summation of Zoppo's Paduan experience. The *recto* is profoundly Donatellesque. The sculptor's bronze relief of an idealised half-length Dead Christ mourned by

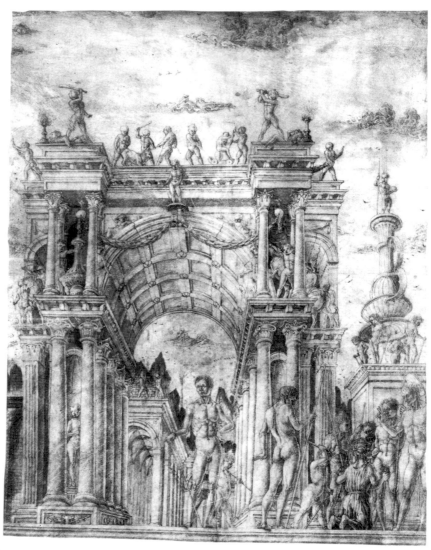

8 *verso*

two weeping putti (fig. 2), part of the Santo altarpiece, is the most direct inspiration for Zoppo's treatment of the theme. Donatello also carved, with studio assistance, a marble relief depicting the half-length figure of Christ supported by putti. The latter work, now in the Victoria and Albert Museum, may well have been executed in Padua (see Pope-Hennessy, 1968, p. 56), and Zoppo may have taken from it the idea of a putto supporting the lolling head of Christ. The classical tabernacle behind the tomb, like the arch in Schiavone's painting (cat. no. 12), is made up of elements which derive from Donatello-school reliefs of the Virgin and Child. Such settings are a common feature of Paduan paintings (see figs 5, 7 and 12), but in the drawing Zoppo adds imaginative touches to the standard repertoire of decorative motifs, most notably the *all' antica* reliefs. In the drawing Zoppo moves beyond the relief-like composition of his earlier Louvre painting to one with a greater sense of recession. He carefully defines the space, even to the extent of placing two of the putti supporting Christ on planks, the ends of which project beyond the edge of the sarcophagus.

The drawing on the *verso* is a highly original reworking of Mantegna's Ovetari fresco. As in the chapel the scene is set just above eye-level with the feet of the two foremost nudes projecting beyond the base, and the composition dominated by an imposing classical arch. Perhaps inspired by Mantegna's preliminary drawing for the fresco (see cat. no. 7) Zoppo's figures, except for the kneeling Josiah, are unclothed. But Mantegna's reasons for drawing nude figures is to study more closely their poses, while in the ex-Colville drawing the nudity of Zoppo's figures is an end in itself. The drawing allows Zoppo to display his ability to depict the male nude. He includes figures in mannered *contrapposto* poses, like the two men in the centre who play no part in the narrative, as well as putti engaged in violent movement.

Zoppo appropriates the basic form of Mantegna's triumphal arch but strips it of its function as a device to isolate the main group. It becomes instead an artistic feature in itself, on which the bizarre actions of the putti can take place, separate from the group in the right foreground. The austere grandeur of Mantegna's arch is not in keeping with Zoppo's taste for abundant decorative detail, and his replacement is enlivened by swags, reliefs and a rich array of capitals. It is not clear if the figures inhabiting the arch are intended to be read as living or as sculpted decorative figures, whose violent antics are mirrored by the boy about to strike the kneeling Josiah. The *gravitas* of Mantegna's fresco is entirely lacking in Zoppo's more playful, almost whimsical version of the composition, which in a display of levity includes a Gattamelata-like putto riding a horse on the triumphal arch and another surmounting the classical monument on the right, where one would expect to find an emperor or king.

The nature of Zoppo's borrowings in the drawing display his debt to Donatello and Mantegna while revealing his independence in the manner in which he interprets their work. One can only conjecture why he made such a drawing. It may have been drawn as a finished work for sale, or perhaps it served as an example of his skill to be shown to prospective clients in his newly established studio. It may even have come from a series of such drawings in an album (cf. cat. nos 11, 15 and 16). Whatever the function of the drawing, it is a powerful reminder of the crucial role that Padua played in the formation of Zoppo's artistic character.

9 Andrea Mantegna (c. 1431–1506)

A saint reading

Pen and brown ink, brown wash, on pink prepared paper. 172 × 70 mm

Provenance: T. Lawrence (L. 2445); J. C. Robinson; J. Malcolm

Exhibited: London and New York, 1992, no. 24; London, 1996, no. 4

Literature: Robinson, 1876, p. 119, no. 333; Popham and Pouncey, 1950, p. 8, no. 11, pl. X; Lightbown, 1986, pp. 481–2; D. Ekserdjian in Exh. London and New York, 1992, pp. 175–6, no. 24 (with further literature)

British Museum (1895-9-15-780)

This drawing and a study of three standing saints in the Pierpont Morgan Library (see Exh. London and New York, 1992, pp. 173–4, no. 23) appear to be related to an unknown painting or fresco, executed at the end of Mantegna's Paduan period or soon after his arrival in Mantua. The reading saint seen from below in this drawing is particularly close to the figure on the right of the Pierpont Morgan drawing, albeit in reverse, and he holds the open book with both hands. The unusually well-preserved ink in the present drawing reveals the variety of pressure exerted by Mantegna on the pen as he clarifies the complex folds of the saint's drapery. In contrast with the earlier study of *Saint James on his way to execution* (cat. no. 7) the strokes of parallel hatching are more varied and descriptive, combining both straight and slightly curving lines, and they define the form with greater precision. The use of a coloured ground as a warm mid-tone (created by lightly rubbing red chalk onto the paper) is also found, though in a more faded state, in the study for the Ovetari chapel (cat. no. 7). Mantegna seems to have favoured the technique of pen and ink on prepared ground at the beginning of his career, as he also uses it in another drawing from the late 1450s or early 1460s, the *Saint John the Baptist with a donor*, now in the Walker Art Gallery in Liverpool. Pisanello is known to have made drawings using this technique and Filippo Lippi, who worked in Padua in the 1430s, also favoured strongly coloured grounds, for example the salmon-pink preparation used in the silverpoint study of a female saint in the British Museum (Popham and Pouncey, 1950, pp. 90–1, no. 150).

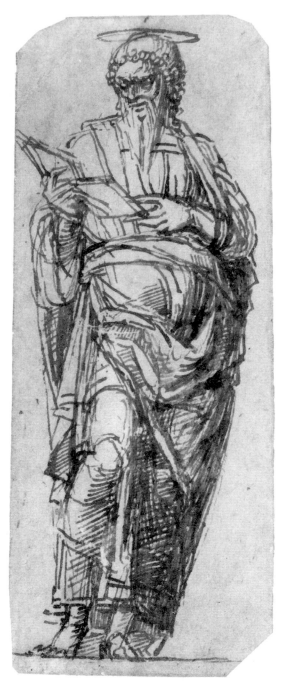

9

10 Andrea Mantegna (*c.*1431–1506)

Three studies of the Dead Christ

Pen and brown ink. 122 × 89 mm

Provenance: J. C. Blofeld

Exhibited: London and New York, 1992, no. 26

Literature: Popham and Pouncey, 1950, p. 8, no. 12; D. Ekserdjian in Exh. London and New York, 1992, pp. 177–8, no. 26 (with further literature); M. Hirst, 1992, p. 321; Goldner, 1993, p. 174

British Museum (1909-4-6-3)

As with a number of early Mantegna drawings, this study has sometimes been ascribed to his brother-in-law Giovanni Bellini. The attribution to Mantegna is now generally accepted by modern scholars. The studies of the Dead Christ are related to a study of the *Entombment* in Brescia (see Exh. London and New York, 1992, no. 27), and both works may be preliminary ideas for an engraving attributed to Mantegna of the *Entombment with four birds* (Bartsch XIII, 228.2). In the present study Christ is shown lying on the ground and not, as in the Brescia drawing and the engraving, being lifted into the tomb on a winding sheet. It is possible that at this early stage in the development of the composition Mantegna may have considered showing Christ laid out on the stone of unction, as in his later painting of the *Dead Christ* in the Brera. Stylistically, the drawing is close to the study of *Saint James on his way to execution* (cat. no. 7), especially in the schematic figural style adopted

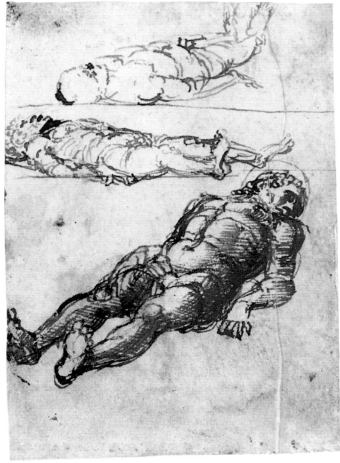

10

in the upper two studies which recalls the right-hand side of the latter sheet. Mantegna, in the most fully worked study of the Dead Christ below, made a number of revisions to the outline of the figure, adding darker accents in areas such as the outline of the shoulders, and in the heavily shaded section by the left hip. The hatching used to define the figure is denser and employs more cross-hatching than the earlier Saint James drawing, but this probably reflects the different functions of the drawings rather than a change in style. The *Saint James on his way to execution* is a rapid first idea for a composition, while the aim of the present drawing is to explore a single figural motif. Particular care has been taken in the disposition of the light, with the blank paper acting as a highlight, often in proximity with heavily inked areas. This contrast is most brilliantly exploited in the moving description of the head of the Christ, whose sunken features and downturned mouth convey the extent of his suffering.

Wilde's suggested dating to the early 1460s was accepted by Ekserdjian; Hirst and Goldner favour placing the drawing at the end of the Paduan period because the slightly awkward foreshortening of the figures is also found in the sleeping apostles in Mantegna's two paintings of the *Agony in the Garden* from the late 1450s (Tours, Musée des Beaux-Arts and London, National Gallery).

11 Jacopo Bellini (c. 1400–70/1)

Album of Drawings: the Entombment (folios 22 verso and 23 verso)

Leadpoint. 415 × 336 mm

Provenance: Mentioned in the will of the artist's widow in 1471 and bequeathed to Gentile Bellini (d. 1507); inherited by his brother Giovanni (d. 1516); Gabriele Vendramin; Jacopo Soranzo; Marco Cornaro (d. 1779); Count Bonomo Algarotti; the Corniani family; acquired in 1802 from Bonetto Corniani by Giovanni Maria Sasso (d. 1803); Girolamo Mantovani, sold to his brother Domenico; inherited by his heir Giovanni Mantovani; purchased in 1855 by Rawdon Lubbock Brown, acting as agent for the British Museum

Literature: Popham and Pouncey, 1950, p. 14,

no. 21 (with previous literature); Röthlisberger, 1956, pp. 358–64; Eisler, 1989, pp. 352–3, pls 215–16; Degenhart and Schmitt, 1990, II–6, p. 465, II–8, pls 163–4; Humfrey, 1993 (I), p. 178, pls 168–9; Elen, 1995, pp. 213–17, cat. no. 21 (with further literature)

British Museum (1855-8-11-21 *verso* and 1855-8-11-22 *recto*)

The largest number of Venetian Renaissance drawings in existence by a single artist are contained in two albums by Jacopo Bellini, one in the British Museum and the other in the Louvre. The two works were originally of identical length – 102 pages – but the London album drawings are on paper, while the Paris book is made up of vellum leaves. The drawings in the British Museum book are almost entirely executed in leadpoint, while those in the Louvre are for the most part either in metalpoint or pen and brown ink (sometimes with wash). The Louvre album, which contains more highly finished drawings, is generally considered to date from the 1450s and 1460s. The London book is usually believed to be the earlier of the two, dating from the 1440s or 1450s. Degenhart and Schmitt have recently argued in favour of a reversal of this chronology. They suggest instead that the Paris drawings are earlier and should be dated to the period 1430–55, with the majority executed in the 1430s; and that the drawings in the London book date between 1455 and the artist's death.

Because of the way in which the Louvre album is constructed (see Elen, 1995, p. 221) the wide range of dates which Degenhart and Schmitt assign to the Louvre drawings on stylistic grounds appear less plausible than the dating proposed by Röthlisberger, Eisler and other scholars. They propose that both albums are from much the same period and were started either in the 1440s or 1450s and finished in the 1460s (for the complex question of the dating, see Eisler, 1989, pp. 99–104, and Degenhart and Schmitt, 1990, II–5, pp. 103–91). This view is supported by the fact that some of the drawings in the London album, including those exhibited here, appear to have provided the basis for more elaborate compositions in the Paris book. Both albums were probably intended as

model or pattern books, a repertory of compositional ideas to be used for paintings and for instruction. Perhaps it is not coincidental that the more highly worked Louvre drawings were presented by Jacopo's son Gentile to the Sultan during his official visit to Constantinople in 1479–81, while the London album, the drawings in which are more exploratory in nature, remained in the family until the death of Giovanni in 1516.

The subject of the present drawing is one frequently found in Gothic painting. But Bellini's treatment differs from traditional representations of the theme, most notably in the larger number of figures gathered around the tomb and the evocative landscape setting. On the left-hand page Bellini shows the earlier episode of the Lamentation at the foot of the cross, with the prone figure of the dead Christ lying across the legs of the seated Virgin. There is a similar composition in the Louvre album (Degenhart and Schmitt, 11–7, pl. 41; Eisler, pl. 214). On the other page Saint John holds Christ upright in the tomb which, in keeping with the artist's antiquarian taste, takes the form of a classical sarcophagus with a richly carved lid. A corner of a similar lid appears at the edge of a recently discovered painting by Jacopo of *Saints Anthony and Bernardino* (private collection on loan to the National Gallery of Art, Washington), which is probably the left-hand panel of an altarpiece of 1459–60 commissioned by the widow of the mercenary Gattamelata for a funerary chapel in the Santo in Padua (see Humfrey, 1993, I, pls 167 and 170). The probable dimensions of the central panel would not have allowed a composition with as many figures as the *Entombment* drawing, but Bellini may have adapted it to fit the space or selected a related theme, such as a Dead Christ with angels or putti. Giovanni Bellini, in his depictions of the Entombment, most notably in the paintings in the Brera and the Vatican, may well have taken inspiration from his father's exploration of the theme in the five drawings of the subject contained in the albums.

12 Giorgio Chiulinovich, called Giorgio Schiavone (?1433/6–1504)

The Virgin and Child

Tempera on poplar panel; inscribed on the left pilaster: A / E (?) and on the right one: P / Ω (the Greek letter Omega). 57 × 422 mm (panel)

Provenance: Alexander Barker, London by 1871; acquired in 1874

Literature: Davies, 1961, pp. 467–8; Kokole, 1990, pp. 50–6, fig. 1; Baker and Henry, 1995, p. 622

National Gallery, London (NG 904)

The composition, with a half-length Virgin in a festooned Renaissance arch, is found in other works executed by Squarcione and his pupils. These include Squarcione's painting in Berlin, Zoppo's *Virgin and Child*, now in the Louvre, and his drawing of the subject in the Rosebery album (figs 5, 7 and 8). The attribution of the present work to the Croatian painter Schiavone (the Slav) is not absolutely certain, as it differs in some respects from his signed works. Yet it is unquestionably the work of an artist in the circle of Squarcione in the second half of the 1450s.

Schiavone signed a contract to study painting with Squarcione for three-and-a-half years in March 1456, six months after Zoppo's departure, and he remained with him in Padua until 1460–1. He was Squarcione's chief assistant and was entrusted with small-scale devotional works, like the present painting, and also with major altarpieces, such as the polyptych painted for the church of San Niccolò in Padua, now in the National Gallery.

Kokole has traced a number of motifs in the present work to reliefs by or after Donatello. The architectural setting and the three pairs of putti in the background correspond closely with those in some Donatellesque terracotta reliefs, versions of which are in the Staatliche Museen, Berlin, the Liechtenstein collection in Vaduz, and the Detroit Institute of Arts. These reliefs are attributed to Donatello's collaborator in Padua, Giovanni da Pisa (see Kokole, 1990, figs 4–6). Similarly, the pose of the Christ Child in the painting is based on a gilt bronze plaquette, now in Washington,

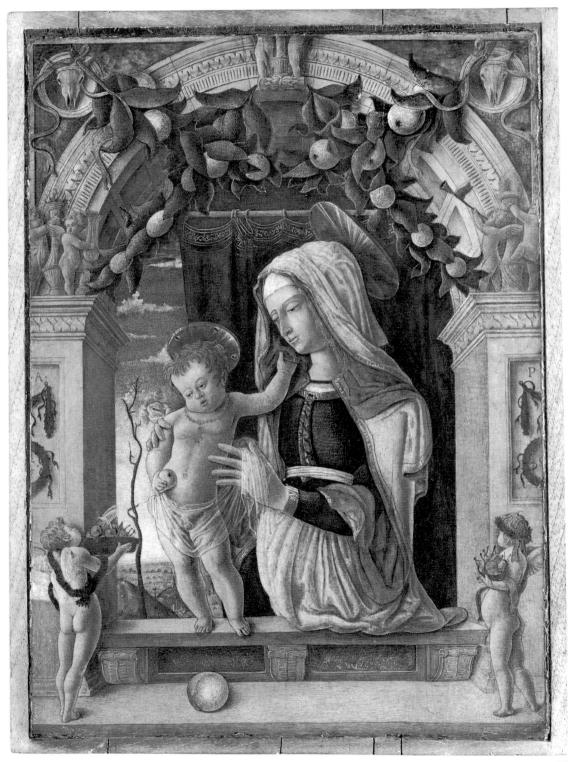

12

ascribed to a Paduan follower of Donatello (fig. 9). The number of copies after the relief, including a painted stucco variant in the Victoria and Albert Museum (fig. 4), attest to the popularity of the image, and Mantegna appears to have borrowed from the same source. The pose of the Christ Child in the relief recurs, with slight variation, in Giovanni Antonio da Brescia's engraving after a lost study by Mantegna of the *Holy Family* (Bartsch, 1803–21, XIII, 320:5), and also in a drawing of the *Virgin and Child* in the Institut Néerlandais, Paris, possibly by Mantegna himself (see D. Ekserdjian in Exh. London and New York, 1992, pp. 229–30, no. 53).

The letters of the inscription on the pilasters are probably the abbreviated form of 'Alpha et Omega, Principium et Finis' ([I am] Alpha and Omega, the beginning and the end) from the New Testament (Revelation 1:8). The painting includes visual references to Christ's future resurrection with the inclusion of a butterfly, symbol of the resurrected soul, as well as a basket of cherries, a fruit associated with Paradise.

13 Cosimo (or Cosmè) Tura (before 1431–95)

The Virgin and Child with Saints Sebastian, Francis, Dominic and Agatha

Pen and brown ink, brown wash; inscribed on the panels of the screen: *horo* (gold). 149 × 215 mm

Provenance: J. Richardson, senior (L. 2184); A. Grahl (L. 1199), his sale, Sotheby's, 28 April 1885, lot 200 bt. by Thibadeau for the British Museum

Exhibited: Milan, 1991, no. 84

Literature: Parker, 1927 (I), p. 26, pl. 21; Popham and Pouncey, 1950, p. 158, no. 256, pl. CCXVII (with previous literature); Ruhmer, 1958, pp. 37–8, 174–5, fig. 44; M. Ferretti in Exh. Milan, 1991, pp. 337–42, no. 84, fig. 367 (with further literature); Dunkerton, 1991, p. 144, fig. 183

British Museum (1885-5-9-1613)

Acquired as a work by Filippo Lippi in the Grahl sale, the drawing was attributed to Tura by J. P. Richter. Drawings by the artist are extremely rare. Apart from the present work only three others, all executed in brush and grey wash heightened with white, are generally accepted as being securely autograph: the allegorical *Female figure* in Berlin, *Hercules and the lion* in the Boymans Museum, Rotterdam, and the *Seated Evangelist reading* in the Uffizi in Florence (see Ruhmer, 1958, figs 13, 70–1). These three drawings are characterised by a freedom of handling which is markedly different from the refined penwork of the present sheet, and has led some scholars to reject its attribution to Tura. The difference in style can be explained by the likely function of the present drawing as a finished design to show to a prospective patron, while the other drawings are preparatory studies executed to explore a particular pose or compositional idea. The repeated inscription 'horo' (gold) on the panels behind the figures in the drawing would serve no purpose in a preparatory study intended for the artist alone, but would make sense if he wanted to give the patron a clear idea of the form of the proposed altarpiece. There is no chalk underdrawing, neither are there any revisions to the outline, and one would normally expect to find both of these in a drawing of this complexity. This suggests that Tura was making a fair copy of a previous compositional drawing.

The dating of works by Tura is extremely difficult as there is no securely documented painting by him prior to the organ shutters of 1460 for Ferrara cathedral. The present drawing is most probably an early work, executed in the years following his return to his native Ferrara in 1456. The previous three-year period (1453–6), in which Tura is not recorded in the city, may have been partly spent in Padua, as elements of his early painting style derive from Squarcione and his school. The early dating for the present drawing, first proposed by Johannes Wilde, is based on its similarities with paintings generally considered to be of the late 1450s or early 1460s. The dolphin-shaped arm-rests of the Virgin's throne recur in the National Gallery *Allegorical figure*, and the physical types, as well as the rope-like drapery folds, are paralleled in the *Virgin and Child with Saints Jerome and Apollonia* in the Musée Fesch, Ajaccio (Ruhmer, 1958, figs 12 and 14). Tura's use

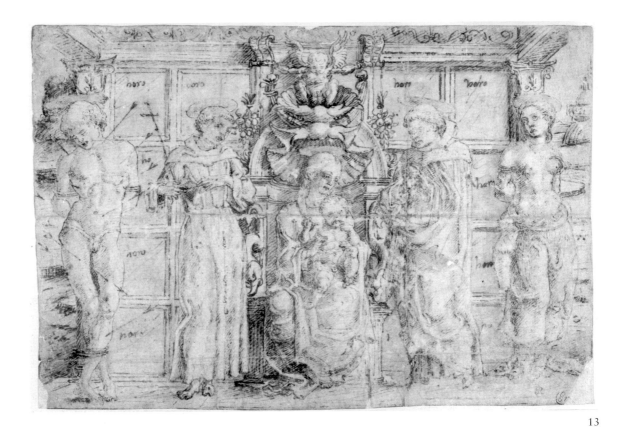

13

of diagonal parallel hatching to indicate the fall of light recalls, albeit in a more delicate fashion, Mantegna's drawings of the 1450s and early 1460s (see cat. nos 7, 9 and 10). The drawing also provides support for the theory that Tura spent time in Padua in the mid 1450s, as the relatively unusual placement of the saints' heads above those of the Virgin and Child is also found in Pizzolo's sculpted relief in the Ovetari chapel (fig. 3). It is possible that the spatial illusionism was intended to be enhanced, as in Mantegna's San Zeno altarpiece (1456–9), by a frame which would have completed the rectangular form of the open-sided loggia. Both in this drawing and in the painting now in the Musée Fesch, Tura creates a sense of measurable space by means of the architrave projecting forward and the careful delineation of the platform on which the figures stand.

14 Attributed to Giovanni Bellini (c.1431/6–1516)

The Pietà

Pen and brown ink, with (later?) brown wash; inscribed upper right: *Udini* (?). 130 × 94 mm

Provenance: T. Lawrence (L. 2445); J. C. Robinson; J. Malcolm

Exhibited: London, 1996, no. 5

Literature: Robinson, 1876, p. 123, no. 344; Parker, 1927 (I), pl. 42; Parker, 1927 (II), p. 50; Tietze and Tietze-Conrat, 1944, p. 92, no. 343; Popham and Pouncey, 1950, pp. 8–9, no. 13, pl. XII; Heinemann, 1963, p. 213, fig. 624; Robertson, 1968, p. 25, footnote 3; E. Saccomani in Exh. Rennes, 1990, p. 34, under no. 11

British Museum (1895-9-15-791)

The drawing, catalogued by Robinson in the Malcolm catalogue as 'uncertain North Italian', was attributed to a follower of Bellini by Karl Parker in 1927. He suggested that the inscription

14

'Udini' in the upper-right corner might refer to the Friulian painter Giovanni Martini da Udine (c.1453–1535), a provincial and rather feeble follower of Giovanni Bellini. The same year Parker published a drawing of the same subject at Rennes, which he attributed to Bellini. He proposed that the British Museum study derived from the Rennes drawing. The Tietzes cautiously accepted Parker's attribution for the Rennes sheet, agreeing that the present drawing should be given to Martini. In support of this attribution, they noted a similarity in type between the Christ Child in Martini's painting of the *Holy Family with Simeon* of 1498 in the Museo Correr in Venice (see Berenson, 1957, I, pl. 489) and the studies of children on the *verso* of the present drawing (illustrated in Popham and Pouncey, 1950, II, pl. XII). Popham and Pouncey felt that the present drawing and the Rennes sheet were by the same hand, and that both were probably studies for an unknown composition by Bellini, possibly from the mid 1470s. They suggested that the bad impression which the British Museum drawing gives at first glance was due to the wash, which they felt was a later addition. Heinemann rejected their argument, ascribing the drawing to an anonymous follower of Bellini who had taken the composition from the Rennes study.

The disagreements regarding the status of this drawing are due, at least in part, to the lack of a single pen drawing which can be unequivocally attributed to Bellini on the basis of a connection with one of his paintings. The problem of attributing drawings to his hand on the basis of style and quality alone has been complicated in addition by a trend to assign drawings to Bellini which are now generally regarded as being early studies by his brother-in-law Mantegna. All of the Mantegna drawings included in the present exhibition, even the study for the Ovetari chapel fresco (cat. no. 7), have at one time been considered the work of Giovanni Bellini. The confusion between the two artists is understandable because the pen studies with the best claim to be by Bellini are similar to Mantegna's drawings of the 1450s and 1460s, especially in their manner of hatching and the wiry outlines of the figures. Examples of such Mantegnesque drawings ascribed to Bellini include

the Louvre *Pietà*, the *Nativity* in the Courtauld Institute and *Saint Mark healing Anianus* in Berlin (see Robertson, 1968, pls V and LII).

The Rennes drawing and the present work are so alike in handling, especially in the nervous quality of the penwork in those details where the artist has repeatedly amended the outlines, that it is hard to imagine that they are not by the same hand. If this is the case, the British Museum drawing is most likely the later of the two, because the areas in the Rennes sheet where the artist has searched to find the right pose – such as the position of the Virgin's legs – are drawn with almost no amendments in the present work. The relationship between the two figures in the British Museum drawing is, in comparison with the Rennes study, more coherent and affecting. In the British Museum drawing the Dead Christ is seated sideways on the Virgin's lap and not, as in the Rennes drawing, in a more awkward frontal pose. In addition, the posture of the Virgin in the present drawing is simplified. She draws her son closely to her body, cradling his head with her left hand in a touching embrace made more poignant by the proximity of the tomb where he will shortly be laid. The expressive quality of the heads in both drawings, achieved with a great economy of line, is the strongest link between these works and the aforementioned group of Mantegnesque drawings given to Bellini. This connection is unquestionably tenuous and the differences between the drawings could only be explained if the Rennes and the British Museum studies are from a later period. These last two drawings have been dated to the mid 1470s on the basis of a comparison with Bellini's paintings of the same decade. In Bellini's Pesaro altarpiece from this period, the panel of the *Pietà* (now in the Vatican) shows the Dead Christ seated sideways on the tomb, with one hand on his thigh. This pose is reminiscent of that of Christ in this drawing. The compositional inventiveness and the moving expression of emotion in the Rennes and British Museum drawings are worthy of Bellini, but unless a related painting comes to light, the attribution must remain a tentative one.

15 Marco Zoppo (1432/3–78)

The Rosebery Album: a bust-length study of a youth; three putti and a dog with four figures behind

Pen and brown ink, 18 *recto* with brown wash, on vellum; 18 *recto* inscribed: *MIIII* and 23
218 × 158 mm

Provenance: Matteo Macigni (d. Padua 1582); Giambattista de Rubeis; Pietro Antonio Novelli; Samuel Woodburn, his sale, Sotheby's, 27 June 1854, lot 2321, £220.10s. bt. Barker; Alexander Barker; Baron Mayer de Rothschild; Earl of Rosebery, by whom presented to the British Museum

Exhibited: London, 1877–8, no. 1238

Literature: Dodgson, 1923 (with previous literature); Popham and Pouncey, 1950, pp. 162–3, no. 260;

Fig. 23 Marco Zoppo, detail of emblem on the sleeve of a figure in *Four figures in converse*, pen and brown ink, page 17 *recto* of Rosebery Album (British Museum)

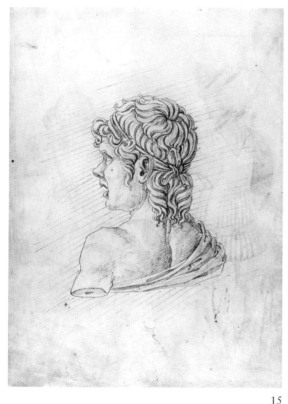

15

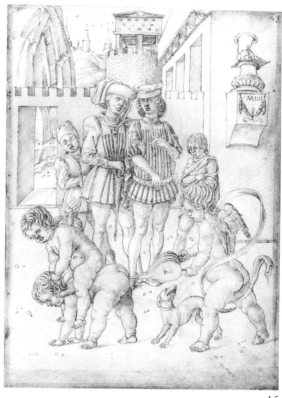

15

Ruhmer, 1966, pp. 77–81, all the drawings
reproduced figs 88–135; Armstrong, 1976,
pp. 228–319, 417–23, no. D.19, all the drawings
reproduced; A. Angelini in Exh. Florence, 1986,
pp. 64–5, under no. 53; De Nicolò Salmazo, 1989,
p. 21, footnote 21; Ames Lewis, 1990, p. 666; Lucco,
1993, p. 112; Armstrong, 1993, pp. 79–95; Elen,
1995, pp. 236–40, no. 29 (with further literature)

British Museum (1920-2-14-1 (17) *verso* and
1920-2-14-1 (18) *recto*)

This album of fifty drawings on vellum was pre-
sented to the British Museum by Lord Rosebery in
1920. Its provenance can be traced back without
interruption to the end of the eighteenth century
when it was given to the Venetian painter Pietro
Antonio Novelli by Giambattista de Rubeis, who
had bought it in Padua. It is also likely to have been
in the city during the sixteenth century, because
an inscription on one of the pages (26 *verso*, origi-
nally page 1) records that it once belonged to
Matteo Macigni, who died there in 1582. While
the album was in the possession of Novelli it was
engraved – except for folios 22 and 25, which
both include female nudes – by the artist's son
Francesco in a publication entitled *Disegni del
Mantegna*, the dedication of which is dated 1795.
The style of binding and the Italian lettering on the
spine would suggest that the drawings were
rebound in Italy, most probably in Venice, prior to
their purchase by the greatest English prints and
drawings dealer of the period, Samuel Woodburn
(1786–1853). The album was included in the
latter's posthumous sale as a work by Mantegna,
when it was purchased by Alexander Barker, who
later sold it to Baron Mayer de Rothschild. The
album passed by marriage to Lord Rosebery,
who was persuaded by Colvin, Keeper of the Prints
and Drawings Department, to present it to the
Museum. In Dodgson's introduction to the 1923
facsimile of the album he tentatively suggested that
the drawings might be the work of Zoppo. This
attribution has never been doubted since.

The drawings in the album are comparable in handling and figure style to the ex-Colville sheet (cat. no. 8) and a study in the Uffizi (Armstrong, 1976, pp. 396–7, no. D.3). Both the latter drawings are dated by Armstrong to the second half of the 1450s, and on stylistic grounds the album can be assigned either to the same period or to the first half of the 1460s, when the artist is known to have been in Bologna. The later dating is perhaps more likely, as the stylised architectural setting of Zoppo's drawing for the manuscript of Marcanova's *Collectio Antiquitatum* (Biblioteca Estense, Modena), finished in Bologna in 1465, is similar to that in some of the backgrounds in the Rosebery album. The Donatellesque *Madonna and Child* drawing (fig. 8), which recalls his Louvre painting of the same subject dating from his period in Padua (fig. 7), also provides grounds for placing the album in Zoppo's early period.

The function of the album has been much debated because, unlike the *Florentine Picture Chronicle* (cat. no. 16), it does not follow an established text and it is too highly finished and specialised in its imagery to have been a pattern book like that of Jacopo Bellini (cat. no. 11). The suggestion that the drawings on the *rectos* illustrate a single Renaissance text (for this see Armstrong, 1976, pp. 311–19) appears unlikely because the subjects are so disparate; in addition, the single religious image is difficult to accommodate into such a theory. Some of the drawings, such as the *Horseman with three nudes* (22 *recto*), may indeed have been inspired by literary sources, but the majority of the drawings on the *rectos* seem to have been intended to be enjoyed for their wit and invention rather than as illustrations to a text. The homosexual overtones of the exhibited folio, in which the action of the putti is underscored by the older man grasping the pommel of his dagger (a gesture pointed out by his youthful companion), is found – albeit in less explicit form – in details of other drawings. These include the phallic shape of the club held by a putto (19 *recto*; fig. 13) and the two men who point to each other's groins while one holds the other by the belt in the background of a scene with wrestling putti (9 *recto*). Together with the deliberately obscure meanings of many of

the drawings, this imagery may indicate that the album was a private commission, intended to be enjoyed and understood by a small circle of the patron's friends. Zoppo may have been following an iconographic programme, but the fact that the most common subject on the *rectos* is that of putti or infants playing or fighting, which is a theme first found in cat. 8, suggests that the artist enjoyed some freedom in the choice of subject-matter. This would be in keeping with an interpretation of the album as primarily an inventive work, in which Zoppo was able to express his imaginative power, rather than as an adjunct to a text.

The identity of the supposed patron is unknown. The light-hearted references to antiquity, such as the foot on the pedestal in the exhibited drawing, would indicate a patron with humanistic interests, who might have known Zoppo through a shared friendship with Felice Feliciano. Mauro Lucco proposed that the patron may have been a member of the Corner family, as the form of the shield held by the putti in one of the drawings (19 *recto*; fig. 13) is similar to the family's shield included in Zoppo's painting of the *Madonna and Child* in Washington (Vigi (ed.), 1993, pp. 168–9). But unfortunately they are not close enough to make the identification secure. A clue to the patron's identity may be furnished by a hitherto overlooked detail in one of the groups of conversing figures (17 *recto*; detail fig. 23). On the sleeve of a figure on the far right there is an emblem of a vice squeezing drops of moisture from an object that resembles a stylised leek. Such personal emblems embroidered on sleeves are found in portraits of the period, such as Baldovinetti's *Portrait of a lady* in the National Gallery; but as in the present case, they can rarely be identified.

Lilian Armstrong has recently suggested that the *all'antica* heads in the album were originally drawn as designs for woodcuts to illustrate a printed edition of Petrarch's *De viris illustribus* in an Italian translation published by Felice Feliciano and Innocente Zileto in 1476. According to her theory, Zoppo's drawings were unaccountably not used for the book, and in order not to waste his work he bound them in an album, adding figurative drawings on the other side, which he copied from his

stock of drawings in the studio. Quite apart from the lack of documentary evidence and the radical re-dating of the drawings needed to accommodate any connection with the 1476 book, Armstrong's idea is, as Elen noted, disproved by the fact that Zoppo did not use the smooth (or flesh) side of the vellum for all the head studies, as one would expect if they were all drawn first. The alternation between hair and smooth sides shows, on the contrary, that the drawings were executed specifically for the album. The minimal underdrawing in chalk and stylus, and the absence of revisions, do suggest that Zoppo probably worked from preliminary studies, but the stylistic uniformity strongly indicates that they were drawn in a concentrated period, most likely in the late 1450s or in the first half of the 1460s. *The all'antica* heads provide it with a visual coherence and continuity which would be lacking if it only contained the compositional studies, the subject-matter of which is so diverse. Zoppo transcends the limitations imposed by the uniform bust-length format, giving free rein to his imagination in the variety of facial types and in the fantastic forms of the helmets.

16 Florentine School, first half of the 1470s (workshop of Baccio Baldini?)

The Florentine Picture Chronicle: Hector and Andromache with their two children (folios 36 verso and 37 recto)

Pen and brown ink, brown wash, over black chalk; inscribed: *ETTOR, ADROMANCHA. MOGLIE. ETOR.* 323 × 230 mm (each page)

Provenance: Professor Edward Schaeffer, bt. in Florence about 1840; Hofrat Schlosser of Neuburg; inherited by his nephew, Baron von Bernus, his sale, Prestel, Frankfurt, 1872, bt. M. Clément of Paris, by whom sold to John Ruskin, 1873; purchased from Ruskin in 1889 (except for six leaves which were later presented to the British Museum)

Literature: Colvin, 1898, p. 59; Popham and Pouncey, 1950, pp. 173–5, no. 274; Degenhart and Schmitt, 1968, 1–2, nos 566–620, 1–4, pls 385–439a; Whitaker, 1994, pp. 181–96; Elen, 1995, pp. 242–7, no. 31 (with further literature)

British Museum (1900-5-26-6 and 1889-5-27-55)

The *Florentine Picture Chronicle* is a book of fifty-five leaves with drawings executed in pen and brown ink. It was attributed to the Florentine goldsmith and printmaker Maso Finiguerra (1426–64) by Sidney Colvin in 1898, but it is now generally regarded as a product of the workshop of his pupil Baccio Baldini (*c.*1436–*c.*1487), dating from the first half of the 1470s. The book is first recorded in the possession of Professor Schaeffer of Heidelberg, who bought it in Florence in the 1840s. After passing through a number of hands it was acquired for £1,000 in 1873 by John Ruskin, who was a passionate advocate of the superiority of Gothic and early Renaissance art and architecture over later styles. While it was in Ruskin's possession he removed the binding, which was not the original one, and mounted some of the drawings individually. Ruskin gave away six of them, but they were later reunited with the others from the album in 1890 and 1900. Ruskin sold the *Chronicle* to the British Museum in 1889, and in 1898 Colvin published a facsimile of the work, which lacked the four drawings presented to the Department in 1900 by Ruskin's cousin. When the drawings were all reunited they were rebound and put back in the original order following the numeration at the upper-right corner on the *recto* of each sheet. The numbering begins with '5', but it is thought that the first four pages were already missing before the album was broken up by Ruskin.

Lucy Whitaker has convincingly argued that the varying quality of the drawings in the book suggests that it is the work of two or more hands working in the same workshop, probably that of the aforementioned Florentine goldsmith and printmaker Baccio Baldini. The artists responsible appear to have utilised pattern books, as a number of motifs are exactly repeated or repeated with slight variations throughout the album. The sources for the figures include drawings by Baldini's master, Maso Finiguerra, and works post-dating his death in 1464, such as Antonio Pollaiuolo's embroidery designs for the Florentine Baptistry vestments (*c.*1466–80). The technique and style of the drawings are closely related to prints attributed to Baldini, and it is possible that he also had a hand in the execution of the *Chronicle*.

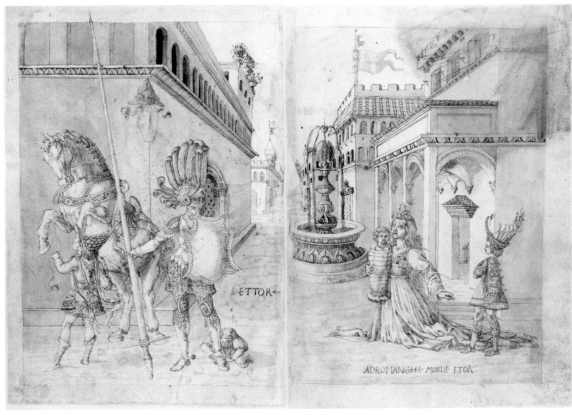

ETTOR

ADROMANGHA · MOGLIF ETOR.

The book is loosely based around the scheme of a 'world chronicle', in which history is divided into six ages. The last drawing in the work shows Milon of Croton, who is placed in the fourth age. This suggests that the *Chronicle* was never completed, or perhaps only part of the book survives. Certain figures taken from the Bible, mythology and ancient history represent each age. Such an idea was possibly inspired by Masolino's lost frescoes of famous men (*uomini famosi*) painted in the early 1430s in Cardinal Giordano Orsini's palace in Rome. Practically all the figures in the book are identified, so that there is no need for a text to understand the meaning of each figure. The book may have been produced as a luxury item for sale, or was perhaps specifically commissioned by an unknown patron. The drawings appear to have been made in roughly the same order as the existing pagination because they become progressively more sumptuous in their detail and more complex in composition. The artists gradually abandoned the tier structure used in the first quarter of the book, adopting instead full-page or, as in the present opening, double-page settings.

The two pages exhibited show Hector, his wife Andromache, and their two sons Laomedon and Astyanax, in an architectural setting reminiscent of Florence. On the left, the Trojan warrior Hector prepares for battle, with a servant fastening his spur while another holds his rearing horse. Andromache, on the right-hand page, pleads with her husband not to leave the city. The fancy armour and the minutely rendered exotic costume are conceived in much the same spirit as Zoppo's Rosebery album (cat. no. 15).

17 Marco Zoppo (1432/3–78)

Profile bust of a woman wearing a helmet

Pen and brown ink, on vellum; inscribed on the helmet: *PAX*. 172 × 120 mm

Provenance: Charles Fairfax Murray

Literature: Hind, 1938–48, I, p. 261, under no. 32; Popham and Pouncey, 1950, p. 165, no. 265, pl. CCXXVII; Ruhmer, 1966, no. 51; Armstrong, 1976, p. 415, no. D.17, fig. 56 (with further literature)

British Museum (1891-6-17-25)

The drawing is daintier in handling and more refined in detail than the bust-length studies in the Rosebery album (cat. no. 15), but they are so similar in conception that the attribution to Zoppo seems likely. A double-sided pen drawing by Zoppo on vellum with finished studies of heads, nymphs and putti, now in Berlin, is similarly inspired by studies in the Rosebery album (see Exh. Berlin and Saarbrücken, 1995–6, pp. 269–70, no. 167). It is possible that such highly finished drawings on vellum were produced as independent works.

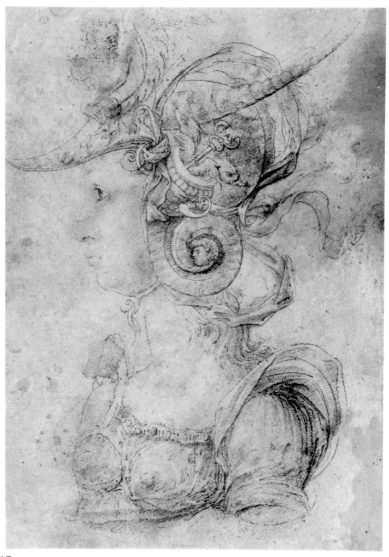

17

18 Marco Zoppo (1432/3–78)

Two centaurs fighting

Pen and brown ink, with (later?) brown wash in the background. 220 × 337 mm

Provenance: J. C. Robinson; J. Malcolm

Literature: Robinson, 1876, p. 119, no. 332; Popham and Pouncey, 1950, p. 165, no. 264, pl. CCXXVIII; Armstrong, 1976, p. 430, no. R.D.4

British Museum (1895-9-15-779)

Attributed to Mantegna in the Malcolm catalogue, it was Colvin who first suggested that the drawing was by the same hand as the Rosebery album. Popham and Pouncey accepted the attribution, comparing it with the scene of battling centaurs (24 *recto*). Ruhmer omitted the drawing in his monograph on Zoppo, and Armstrong rejected the attribution without explanation. This negative assessment may in part be due to the abraded surface of the paper (especially in the lower part), which makes the task of judging the quality of

the drawing more difficult. The visual effect of the drawing is also not enhanced by the wash in the background, which was probably added by a later hand to hide the poor condition of the paper. This has the effect of obscuring the delicate pen hatching behind the figures, which is akin to that found in many of the Rosebery album drawings. The parallel shading in the present study is more even and less vigorous than in the majority of Zoppo's drawings, but is comparable to that in the *Profile bust of a woman wearing a helmet* (cat. no. 17). The case for attributing the drawing to Zoppo is further strengthened by the number of details which are paralleled in the Rosebery album studies. They include the division of hair into thick curls, the rocky landscape setting with a jagged cliff in the foreground, the use of fluttering drapery and the bipartite concave shields. If the drawing is not by Zoppo it must be a copy after one of his studies. The forceful characterisation of the two heads and the confident handling of the sinuous folds of the drapery suggest, however, that it is an autograph

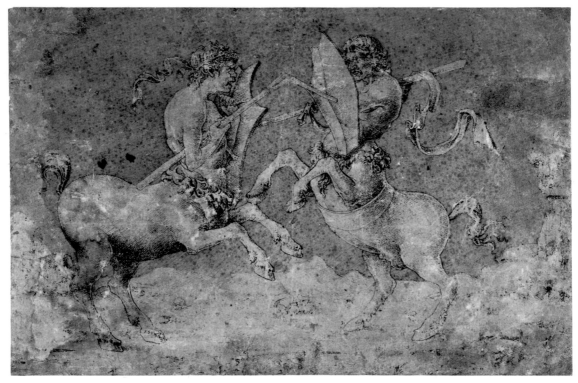

18

study by the master, albeit a damaged one. If, as seems likely, the drawing is by Zoppo, it probably dates from the early or mid 1460s, about the same time as the Rosebery album.

19 Marco Zoppo (1432/3–78)
Studies of the Virgin and Child (recto and verso)

Pen and brown ink, brown wash, on paper tinted pink with red chalk wash. 274 × 182 mm

Provenance: Abbate Pietro Bini; Francesco Novelli; T. Thane (L. 2461); G. Salting, by whom presented to the British Museum

Exhibitions: London, 1912, no. 2; Nottingham and London, 1983, no. 24

Literature: Fry and Dodgson, 1906–7, pp. 11–12, pls 15–16; Fiocco, 1933, pp. 337–51; Popham and Pouncey, 1950, pp. 163–4, no. 261, pls CCXXIV and CCXXV (with previous literature); Ruhmer, 1966, pp. 50–1, 74, figs 66–7; Armstrong, 1976, pp. 158–62, 172–83, 406–7, no. D.9, figs 47–8, Pignatti, 1982, fig. 5; Ames-Lewis, 1990, p. 666; Armstrong, 1993, p. 81; Lucco, 1993, p. 117; Schmidt, 1993, pp. 140–1, *verso* illustrated p. 143; Elen, 1995, pp. 247–9, no. 32, fig. 18

British Museum (1904-12-1-1)

Francesco Novelli's collection of engravings entitled *Disegni di Mantegna*, the dedication of which is dated 1795, reproduced both sides of the present drawing along with all but two of the Rosebery album studies. In a letter of June 1796 Novelli mentions that his friend Giovanni Maria Sasso, the Venetian connoisseur and collector, believed that the present work was by Zoppo rather than Mantegna. Roger Fry and Campbell Dodgson, unaware of Sasso's attribution, published it as a work of Zoppo in 1906–7. Fiocco was the first to suggest that this and the following drawing were, like seven other studies in various European museums, originally part of a dismembered drawing-book with scenes from the life of the Virgin (see Armstrong, 1976, pp. 399–411, nos D.5–D.13). The drawings from this hypothetical drawing-book, known as the Madonna sketchbook, are all executed in pen

and brown ink (some with brown wash) on pink-tinted paper. All of the drawings are double-sided, although only four are complete pages: two others are the upper and lower halves of the same sheet, and the remaining three are fragments of a single drawing.

The drawings from this group are similar in style, the figures drawn with strong outlines and modelled by emphatic diagonal hatching. In comparison with the Rosebery album studies they show a marked shift away from linear elegance towards a more pictorial approach. This is achieved through an increasingly sophisticated use of light and shade, which emphasises the plasticity of the forms and animates the surface textures. Such a stylistic development was probably inspired by Zoppo's contact with Venetian paintings, particularly those of Giovanni Bellini, following his move to Venice in the mid to late 1460s. The Madonna sketchbook studies are generally dated either to this period or to the first half of the 1470s. This late dating is supported by a comparison with Zoppo's paintings of the period. In the painting of the late 1460s of the *Madonna and Child*, now in Washington, the physical type of the Virgin, with her elongated, oval face and prominent forehead, is similar to the figures in the present drawing. In addition, the poses of the Virgin and Child in the same painting, with Christ standing on a cushion and reaching up to his mother's chin, are like those in the upper left study on the *verso*.

None of the drawings in the Madonna sketchbook are directly preparatory for known paintings. However, only two paintings of the Virgin and Child from Zoppo's later period survive (in Washington and Altenburg), and it is possible that some of the five lost half-length versions of this subject listed by the seventeenth-century Bolognese historian Malvasia may have been based on drawings from this group. In the present example, in which Zoppo explores variations of a single motif, he may not have had a specific commission in mind. As is shown by the Washington painting, it is likely that Zoppo turned to drawings such as the present one as a source for compositional ideas when he was commissioned to execute a devotional work of this subject.

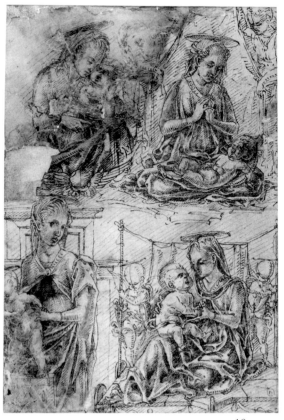

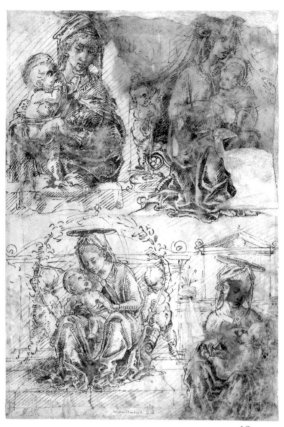

19 *recto* 19 *verso*

The most obvious precedent for such a focused exploration of the theme of the Virgin and Child are the reliefs of Donatello. It is perhaps not coincidental that the likely source for the pose of the figures drawn in the upper left of the *recto*, where the Virgin presses the head of the Christ Child against her cheek, is a lost Donatello relief (the so-called *Verona Madonna*) dating from his Paduan period. The main focus of the present drawing is the Virgin and Child, and the subsidiary figures and settings are drawn in a more summary fashion.

Zoppo's schematic manner of drawing the heads of the putti with a curved line in the centre is a mannerism also found in Mantegna's drawings, as in the background figures in the study of *Saint James on his way to execution* (cat. no. 7). The quickly sketched settings in Zoppo's drawing are, for the most part, conventional, except in the lower-right study on the *recto*, where the Virgin and Child are incongruously seated on a low-slung cart, similar to that shown in two drawings in the Rosebery album (1 and 5 *recto*).

20 Marco Zoppo (1432/3–78)

The Virgin and Child with music-making putti

Pen and brown ink, on paper tinted with red chalk wash. 135 × 109 mm

Provenance: Richard Cosway; Samuel Woodburn, his sale, Christie's, 12 June 1860, lot 1082; Sir Thomas Phillipps; T. Fitzroy Fenwick; presented by the National Art Collections Fund

Literature: Popham and Pouncey, 1950, p. 164, no. 262, pl. CCXXVI; Ruhmer, 1966, p. 77, fig. 87b; Armstrong, 1976, pp. 158, 410, no. D.12, fig. 49; Ames-Lewis, 1990, p. 666; Schmidt, 1993, p. 140

British Museum (1946-7-13-13)

Lilian Armstrong was the first to point out that this is a fragment of a sheet drawn on both sides, which has been cut into three. The upper half, with two studies of the Virgin and Child (the drapery of which appears at the top of this study) is in the Biblioteca Reale in Turin (Armstrong, 1976, p. 408, no. D.10, fig. 49). The lower-right fragment with a single study is in Hamburg (Armstrong, 1976, p. 409, no. D.11, fig. 49).

The drawings on the *versos* of the three sheets are notably freer in handling, using lightly applied wash rather than hatching to indicate the play of light (Armstrong, 1976, fig. 50).

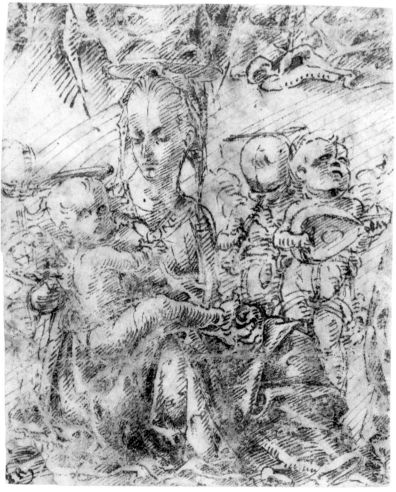

20

21 Andrea Mantegna (1440/1–1506)

The Virgin and Child

Engraving, state 1 of 2. 249 × 210 mm

Literature: Bartsch, 1803–21, XIII, 232:8; Hind, 1948, Part II, v, no. 1; Exh. Washington, 1973, under no. 77

British Museum (1856-7-12-1072)

The engraving, which Hind considered one of Mantegna's earliest, is now generally dated to the 1480s. The later dating is supported by the techni-cal accomplishment shown in the gradation of tone. This is achieved through the varying thickness and direction of the modelling lines, and the skilful juxtaposition of worked passages with areas where the paper has been left blank.

As in Zoppo's earlier drawings of the same subject (cat. no. 19) Mantegna places the figure of the Virgin on the ground, following the fourteenth-century tradition of the 'Madonna of Humility'. The Virgin's loving embrace of the child, with her cheek touching his head (a motif first used in Byzantine icons), is also found in three devotional

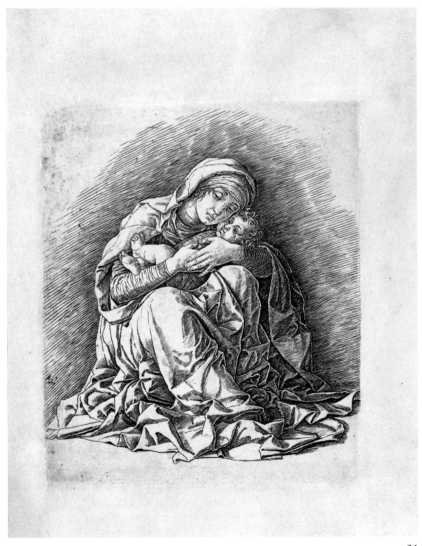

21

paintings of the Virgin and Child by Mantegna: the so-called *Butler Madonna* in the Metropolitan Museum, New York (fig. 6) of the mid 1450s, and two works, probably from the following decade, now in the Museo Poldi Pezzoli, Milan and the Gemäldegalerie, Berlin. The motif also appears in Zoppo's study on the upper-left of the *recto* of the larger of the two drawings from the so-called 'Madonna sketchbook' (cat. no. 19). Mantegna and Zoppo's compositions were both probably inspired by reliefs by Donatello, most notably his so-called *Verona Madonna*. This shows a half-length figure of the Virgin pressing the head of the Christ Child to her cheek. Donatello's original is lost and it is not known if it was executed in marble or bronze. It was widely copied and there is good reason to date it to his Paduan period, as the known version of the work – which is in the Via delle Fogge in Verona – is displayed with casts after two of the Angels from the Santo altar (see Pope-Hennessy, 1976, p. 176). The engraving and the drawing show the continuing importance of Donatello's Paduan work for both artists, an influence which continued long after they had left the city.

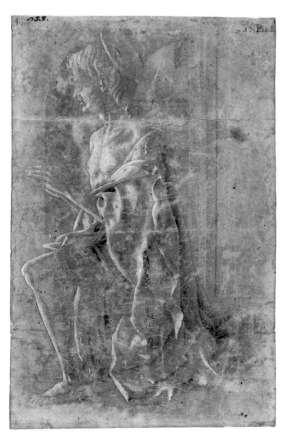

22

22 Marco Zoppo (1432/3–78)

Study of a kneeling saint (John the Baptist?)

Brush and brown wash, heightened with white, over black chalk, on blue paper (faded to brown); inscribed upper right: *di BEL[LINI]*. 258 × 167 mm

Provenance: M. Pujol

Exhibited: London, 1894, no. 76

Literature: Popham and Pouncey, 1950, pp. 165–6, no. 266, pl. CCXXVIII (with previous literature); Fiocco, 1954, p. 228; Ruhmer, 1966, p. 70, fig. 55; Armstrong, 1976, pp. 132–3, 150, 398, no. D.4, fig. 40 (with further literature)

British Museum (1875-7-10-1039)

The drawing was initially attributed to Mantegna, but in the 1894 exhibition of drawings in the British Museum it was given to Zoppo. This attribution has been accepted by all later scholars except for Fiocco, who appears to reject it on the grounds of the unusual chiaroscuro technique. Tonal drawings of this type, executed with the brush only, may well have formed part of Zoppo's artistic education in Squarcione's workshop. The practice is documented in a contract of October 1467 relating to the apprenticeship of a boy called Francesco with Squarcione. At the end of the notary's Latin contract Squarcione wrote in Italian a more specific account of what the apprentice would be taught, and this includes a promise to keep the boy 'with paper in his hand, to provide him with a model, one after another, with various figures in lead white, and to correct these models for him' (an English translation of Squarcione's additions to the contract is given in Gilbert, 1980, pp. 33–4). This method of drawing, in which light rather than line is used to define the form, appealed to Venetian artists. Comparable, albeit later, exam-

ples of brush drawings on blue paper in the British Museum include Vittore Carpaccio's *Three studies of a bishop* of the early 1490s, and Alvise Vivarini's *Head of an elderly man*, datable to the mid 1480s (Popham and Pouncey, 1950, nos 32 and 259). The present drawing, the blue paper of which is badly discoloured, probably dates from the early 1470s when Zoppo was resident in Venice. The handling of the drapery is close to that in the central panel of the Pesaro altarpiece, dated 1471, now in Berlin, and the drawing may be a preparatory study for an unknown painting from this period.

In the early drawing of the *Risen Christ* in the Rasini collection in Milan, which may well date from Zoppo's Paduan period, he employs a somewhat similar technique of metalpoint with white heightening on a grey-green ground (see Armstrong, 1976, p. 393, no. D. 2, fig. 37). But in comparison with the present study the application of bodycolour is more linear and less painterly in effect.

23 Marco Zoppo (1432/3–78)

The fainting Virgin supported by two holy women

Pen and brown ink; inscribed at the top to the left: *Andrea Mantegna*. 234 × 173 mm

Provenance: Samuel Woodburn, his sale, Christie's, 22 June 1854, lot 1267

Literature: Popham and Pouncey, 1950, pp. 164–5, no. 263, pl. CCXXVII; Fiocco, 1954, p. 228; Ruhmer, 1966, pp. 50, 76, fig. 86; Armstrong, 1976, p. 416, no. D.18, fig. 57 (with further literature); J. A. Levenson *et al.*, in Exh. Washington, 1973, under no. 70, fig. 8–2; D. Landau in Exh. London and New York, 1992, p. 201, under no. 39

British Museum (1854-6-28-62)

Popham and Pouncey tentatively attributed this copy after three figures in Mantegna's engraving of the *Entombment* (Bartsch XIII, 229.3; fig. 24) to Zoppo, and all later scholars – except Fiocco – have accepted their suggestion. Stylistically the drawing recalls Zoppo's Madonna sketchbook drawings (cat. nos 19 and 20), and it probably dates from much the same period. Zoppo's fidelity to the print is somewhat unexpected, because when he borrows

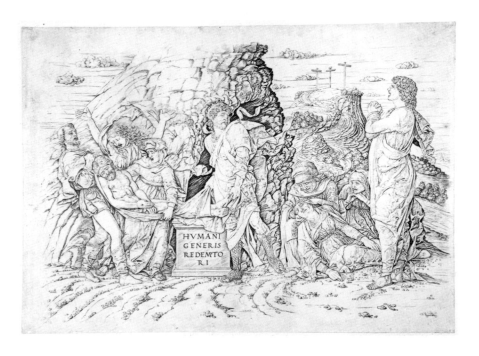

Fig. 24
Andrea Mantegna,
The Entombment,
engraving,
state 2 of 2.
299 × 442 mm.
(British Museum)

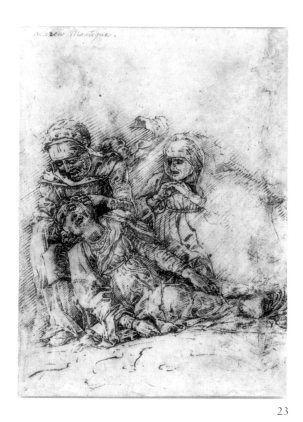

23

Literature: Mayor catalogues, 1871 and 1874, no. 120, 1875, no. 8; Parker, 1927 (I), pl. 20; Byam Shaw, 1934, p. 7; Popham and Pouncey, 1950, p. 114, no. 185, pl. CLXVIII; Byam Shaw, 1976, I, p. 186, under no. 696; De Nicolò Salmazo, in Zeri (ed.), 1987, I, p. 183, fig. 243; De Nicolò Salmazo, 1989, pp. 47, 49 and 53, fig. 24

British Museum (1919-5-10-1)

motifs from other artists he normally interprets them in an original way. If the drawing is auto-graph it would provide a *terminus ante quem* of 1478, the year of Zoppo's death, for Mantegna's print. The paper is very thin in places and a pen design of a candelabrum on the verso is visible on the right-hand side of the *recto*.

24 Bernardino Parenzano, also known as Bernardino da Parenzo (*c*.1450–*c*.1500)

Seated prisoners and trophies, with Victory inscribing a shield

Pen and brown ink; inscribed at top of shield: *S.P.Q.R.*, below: *CC/RA/SDI*, and in the lower-left corner: *PP*. 244 × 208 mm

Provenance: T. Lawrence; W. Esdaile (both according to the Mayor catalogue); W. Mayor (L. 2799); Sir Edward Poynter (L. 874), his sale, Sotheby's, 24 April 1918, lot 76; presented by Sir Edward Poynter

The artist of this and a number of other classically inspired drawings was until fairly recently incor-rectly identified as Bernardo Parentino (1437–1531). He is known to have been a Venetian-born monk, who died in Vicenza. The confusion stems from an account given by the Venetian historian Marcantonio Michiel (*c*.1484–1552) in his *Notizia d'opere di disegno*, which was compiled in the first half of the sixteenth century, but which remained unpublished until its discovery in 1800. Michiel attributed a series of frescoes of the life of Saint Benedict in the Paduan monastery of Santa Giustina to an artist called Lorenzo da Parenzo who, he states, later became an Augustinian monk. Archival research has established that the artist of the Santa Giustina frescoes, which date from the period 1492–6, was in fact Bernardino Parenzano, named after his birthplace in Parenzo in Croatia. The same artist is known to have worked in Mantua for Francesco Gonzaga II in the 1480s. Nearly twenty paintings by him survive, one of which, *Christ carrying the Cross with Saints Augustine and Jerome*, in Modena, is signed. His style as a painter and as a draughtsman depends on that of Mantegna, whose work he would have known from his period in Mantua, and – to a lesser extent – on that of Zoppo. His stay in Mantua coincided with the beginning of Mantegna's work on the *Triumphs of Caesar* canvases (now in Hampton Court), and their densely detailed recreation of the classical world appears to have fired Bernardino with a compa-rable enthusiasm for Roman art and epigraphy.

A companion drawing of approximately the same size is at Christ Church, Oxford (see Byam Shaw, 1976, I, p. 186, no. 696, II, pl. 398). Both are drawn in a dry and somewhat pedantic manner, and the bound figure looking to the left in the present drawing occurs, with minor variations in

the pose, in the Oxford study. The figure of Victory in the British Museum drawing, who is shown writing on a shield and with one foot raised on a helmet, offers the most striking testament to Parenzano's study of Roman art, as its most likely source is a figure on Trajan's column in Rome (see Bober and Rubinstein, 1986, fig. 170a). Similar figures of Victory, as well as the bound captive, recur in the vertical friezes that used to divide the frescoed scenes in Santa Giustina. Only fragments of the frescoes survive, but their compositions are known through engravings (see De Nicolò Salmazo, 1989, figs 33–5). Both the London and Oxford drawings probably date from the artist's period in Padua in the 1490s, as Nicolò Salmazo first

suggested, and may have been intended as finished works in their own right. The significance of the letters on the shield in this drawing, as well as the *GSR* written on the marble parapet in the Oxford study, have yet to be explained. The former might commemorate the names of Roman legions: *CC* (Certa Constans), *RA* (Rapax) and *S* (Seueriana). The letters *DI* at the end can be interpreted as a exhortation to the Spirits of the Underworld (Dii Inferi), who will take care of the soldiers after death. The letters *PP* have sometimes been identified as the initials of the artist (Parentino *pictor*), but they may have been copied from a Latin inscription indicating that a monument has been erected to fulfil an obligation (*pro pietate*).

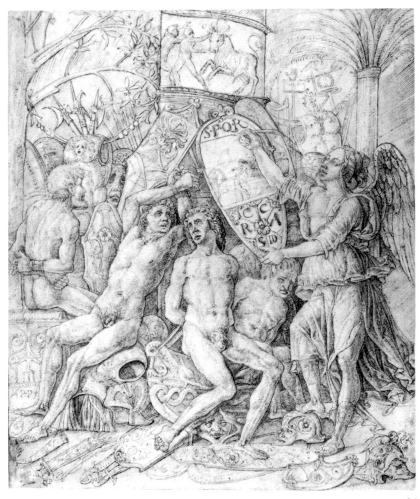

24

Bibliography

Ames-Lewis, 1990
F. Ames-Lewis, 'Il disegno nella pratica di bottega del Quattrocento' in Lucco (ed.), 1990, II, pp. 657–85

Armstrong, 1976
L. Armstrong, *The Paintings and Drawings of Marco Zoppo*, New York

Armstrong, 1993
L. Armstrong, 'Marco Zoppo e il Libro dei Disegni del British Museum: riflessioni sulle teste "all' antica"' in Vigi (ed.), 1993, pp. 79–95

Baker and Henry, 1995
C. Baker and T. Henry, *The National Gallery Complete Illustrated Catalogue*, London

Bambach Cappel, 1994
C. Bambach Cappel, 'On "la testa proportionalmente degradata" – Luca Signorelli, Leonardo, and Piero della Francesca's "De Prospectiva Pingendi"' in Cropper (ed.), 1994, pp. 17–43

Bange, 1922
E. F. Bange, *Staatliche Museen zu Berlin: Die italienischen Bronzen der Renaissance und des Barock, zweiter Teil: Reliefs und Plaketten*, Berlin

Bartsch, 1803–21
A. Bartsch, *Le peintre-graveur*, Vienna, 21 vols

Bell, 1930
C. F. Bell, 'Catalogue of Plaquettes and Medals', MS, Ashmolean Museum

Berenson, 1957
B. Berenson, *Italian Painters of the Renaissance, Venetian School*, London, 2 vols

Bober and Rubinstein, 1986
P. P. Bober and R. Rubinstein, *Renaissance Artists and Antique Sculpture*, Oxford

Byam Shaw, 1934
Byam Shaw, 'A Lost Portrait of Mantegna, and a Group of Paduan Portraits', *Old Master Drawings*, VIII, June 1934, pp. 1–7

Byam Shaw, 1976
J. Byam Shaw, *Drawings by Old Masters at Christ Church Oxford*, Oxford, 2 vols

Canova, 1993
G. Mariani Canova, 'Marco Zoppo e la miniatura' in Vigi (ed.), 1993, pp. 121–35

Chambers, Martineau and Signorini, 1992
D. Chambers, J. Martineau and R. Signorini, 'Mantegna and the Men of Letters' in Exh. London and New York, 1992, pp. 8–15

Colvin, 1898
S. Colvin, *A Florentine Picture-Chronicle*, London, 1898, facsimile of the whole book excluding the four leaves added in 1990

Cropper (ed.), 1994
E. Cropper (ed.), *Florentine drawings at the time of Lorenzo the Magnificent. Papers from a colloquium held at the Villa Spelman, Florence, 1992*, Bologna

Davies, 1961
M. Davies, *The National Gallery Catalogues. The Earlier Italian Schools*, London

Degenhart and Schmitt, 1968
B. Degenhart and A. Schmitt, *Corpus der italienischen Zeichnungen 1300–1450, Teil 1: Süd und Mittelitalien*, Berlin, 4 vols

Degenhart and Schmitt, 1990
B. Degenhart and A. Schmitt, *Corpus der italienischen Zeichnungen 1300–1450, Teil 2: Venedig (Jacopo Bellini)*, Berlin, 4 vols

De Marchi, 1996
A. De Marchi, 'Un raggio di luce su Filippo Lippi a Padova', *Nuovi Studi*, 1, 1996, pp. 5–23

De Nicolò Salmazo, 1987
A. De Nicolò Salmazo, 'La pittura rinascimentale a Padova' in Zeri (ed.), 1987, I, pp. 168–83

De Nicolò Salmazo, 1989
A. De Nicolò Salmazo, *Bernardino da Parenzo, un pittore "antiquario" di fine quattrocento*, Padua

De Nicolò Salmazo, 1990
A. De Nicolò Salmazo, 'Padova' in Lucco (ed.), 1990, II, pp. 481–532

Dodgson, 1923
C. Dodgson, *A Book of Drawings Formerly Ascribed to Mantegna*, London

Dunkerton, 1991
J. Dunkerton *et al.*, *Giotto to Dürer, Early Renaissance Painting in the National Gallery*, New Haven and London

Eisler, 1989
C. Eisler, *The Genius of Jacopo Bellini, the complete paintings and drawings*, New York

Elen, 1995
A. J. Elen, *Italian Late-Medieval and Renaissance Drawing-Books from Giovanni de' Grassi to Palma Giovane, a codicological approach*, Leiden

Exh. Berlin and Saarbrücken, 1995–6
Die italienischen Zeichnungen des 14. und 15. Jahrhunderts im Berliner Kupferstichkabinett, exh. cat. by H. T. Schulze Altcappenberg, Berlin, Kupferstichkabinett and Saarbrücken, Saarland Museum

Exh. Florence, 1986
Disegni italiani del tempo di Donatello, exh. cat. by A. Angelini, Florence, Gabinetto Disegni e Stampe degli Uffizi

Exh. London, 1877–8
The Grosvenor Gallery Illustrated Catalogue: Winter Exhibition (1877–8) of Drawings by the Old Masters and Water Colour Drawings by Deceased Artists of the British School, London, Grosvenor Gallery

Exh. London, 1894
Guide to an Exhibition of Drawings and Sketches by the Old Masters, principally from the Malcolm Collection, exh. cat. by S. Colvin, London, British Museum (2nd edn 1895)

Exh. London, 1912
Exhibition of Drawings and Sketches by Old Masters and by Artists of the English School, London, British Museum

Exh. London, 1930
Italian Drawings exhibited at the Royal Academy, Burlington House, 1930, commemorative exh. cat. by A. E. Popham, London, 1931

Exh. London, 1953
Drawings by Old Masters, exh. cat. by K. T. Parker and J. Byam Shaw, London, Royal Academy

Exh. London, 1994
The Study of Italian Drawings, the contribution of Philip Pouncey, exh. cat. by N. Turner, London, British Museum

Exh. London, 1996
Old Master Drawings from the Malcolm Collection, exh. cat. edited by M. Royalton-Kisch, London, British Museum

Exh. London, 1997
Treasures for Everyone: Works saved by the N.A.C.F. 1980–1995, London, Christie's

Exh. London and New York, 1992
Mantegna, exh. cat. by J. Martineau, K. Christiansen, D. Ekserdjian *et al.*, London, Royal Academy of Arts and New York, The Metropolitan Museum of Art

Exh. London and New York, 1994–5
The Painted Page: Italian Renaissance Book Illumination 1450–1550, exh. cat. edited by J. J. G. Alexander, London, Royal Academy of Arts and New York, The Pierpont Morgan Library

Exh. Milan, 1991
Le Muse e il principe, Arte di corte nel Rinascimento padano, exh. cat. edited by A. Mottola Molfino, Milan, Museo Poldi Pezzoli

Exh. Nottingham and London, 1983
Drawing in the Italian Renaissance Workshop, exh. cat. by F. Ames-Lewis and J. Wright, Nottingham, University Art Gallery and London, Victoria and Albert Museum

Exh. Rennes, 1990
Disegno, les dessins italiens du Musée de Rennes, exh. cat. edited by P. Ramade, Modena, Galleria Estense and Rennes, Musée des Beaux-Arts

Exh. Washington, 1973
Early Italian Engravings from the National Gallery of Art, exh. cat. by J. A. Levenson, K. Oberhuber and J. L. Sheehan, Washington, National Gallery of Art

Fiocco, 1933
G. Fiocco, 'Un libro di disegni di Marco Zoppo' in *Miscellanea di storia dell'arte in onore di Igino Benvenuto Supino*, Florence, pp. 337–51

Fiocco, 1954
G. Fiocco, 'Notes sur les dessins de Marco Zoppo', *Gazette des Beaux-Arts*, XLIII, April 1954, pp. 221–30

Fortini Brown, 1996
P. Fortini Brown, *Venice and Antiquity, the Venetian Sense of the Past*, New Haven and London

Fry and Dodgson, 1906–7
R. Fry and C. Dodgson, 'Marco Zoppo: Eight Studies of the Virgin and Child', *Vasari Society*, series I, part II, pp. 11–12, pls 15–16

Gilbert, 1980
C. E. Gilbert, *Sources and Documents, Italian Art 1400-1500*, New Jersey

Goldner, 1993
Review of Exh. London and New York, 1992 in *Master Drawings*, XXXI, Summer 1993, pp. 172–6

Grandi, 1987
R. Grandi, 'La pittura tardogotica in Emilia' in Zeri (ed.), 1987, I, pp. 222–39

Heinemann, 1963
F. Heinemann, *Bellini e i belliani*, Venice

Hind, 1938–48
A. M. Hind, *Early Italian Engraving*, London, 7 vols

Hirst, 1992
Review of Exh. London and New York, 1992 in *The Burlington Magazine*, CXXXIV, May 1992, pp. 318–21

Holberton, 1989
P. R. J. Holberton, 'Poetry and Painting in the Time of Giorgione', unpublished Ph.D. thesis, London University

Humfrey, 1993 (I)
P. Humfrey, *The Altarpiece in Renaissance Venice*, New Haven and London

Humfrey, 1993 (II)
P. Humfrey, 'Marco Zoppo: La Pala di Pesaro' in Vigi (ed.), 1993, pp. 71–8

Ingamells, 1997
J. Ingamells, *A Dictionary of British and Irish Travellers in Italy 1701–1800, compiled from the Brinsley Ford archive*, New Haven and London

Janson, 1963
H. W. Janson, *The Sculptures of Donatello*, Princeton

Kokole, 1990
S. Kokole, 'Notes on the Sculptural Sources for Giorgio Schiavone's Madonna in London', *Venezia Arti*, IV, pp. 50–6

Kristeller, 1901
P. Kristeller, *Andrea Mantegna*, London

L.
F. Lugt, *Les marques de collections de dessins et d'estampes*, Amsterdam, 1921

Levine Dunkelman, 1980
M. Levine Dunkelman, 'Donatello's Influence on Mantegna's Early Narrative Scenes', *The Art Bulletin*, LXII, 2, June 1980, pp. 226–35

Lewis, 1989
D. Lewis, 'The Plaquettes of "Moderno" and his Followers' in Alison Luchs (ed.) *Italian Plaquettes* (Studies in the History of Art, 22), Washington, pp. 105–42

Lightbown, 1986
R. W. Lightbown, *Andrea Mantegna*, Oxford

Lloyd, 1989
C. Lloyd, 'Two Large Plaquettes in Oxford from the Collection of C. D. E. Fortnum' in Alison Luchs (ed.) *Italian Plaquettes* (Studies in the History of Art, 22), Washington, pp. 207–26

Lucco, 1990
M. Lucco (ed.), *La pittura nel Veneto. Il Quattrocento*, Milan, 2 vols

Lucco, 1993
M. Lucco, 'Marco Zoppo nella pittura Veneziana' in Vigi (ed.), 1993, pp. 107–120

Molinier, 1886
E. Molinier, *Les Plaquettes*, Paris, 2 vols

Parker, 1927 (I)
K. T. Parker, *North Italian Drawings of the Quattrocento*, London

Parker, 1927 (II)
K. T. Parker in *Old Master Drawings*, I, March 1927, p. 50

Pignatti, 1982
T. Pignatti, *La scuola veneta*, Milan

Pope-Hennessy, 1965
J. Pope-Hennessy, *Renaissance Bronzes from the Samuel H. Kress Collection: Reliefs, Plaquettes, Statuettes, Utensils and Mortars*, London

Pope-Hennessy, 1968
J. Pope-Hennessy, *Essays on Italian Sculpture*, London

Pope-Hennessy, 1972
J. Pope-Hennessy, *Italian Gothic Sculpture*, London

Pope-Hennessy, 1976
J. Pope-Hennessy, 'The Madonna Reliefs of Donatello', *Apollo*, CIII, March 1976, pp. 172–91

Pope-Hennessy, 1993
J. Pope Hennessy, *Donatello Sculptor*, New York, London and Paris

Popham and Pouncey, 1950
A. E. Popham and P. Pouncey, *Italian Drawings in the Department of Prints and Drawings in the British Museum: the Fourteenth and Fifteenth Centuries*, London, 2 vols

Ragghianti, 1962
C. Ragghianti, 'Codicillo mantegnesco', *Critica d'Arte*, IX, August 1962, pp. 21–40

Robertson, 1968
G. Robertson, *Giovanni Bellini*, Oxford

Robinson, 1876
J. C. Robinson, *Descriptive Catalogue of Drawings by the Old Masters forming the Collection of John Malcolm of Poltalloch Esq.*, London

Röthlisberger, 1956
M. Röthlisberger, 'Notes on the Drawing Books of Jacopo Bellini', *The Burlington Magazine*, XCVIII, October 1956, pp. 358–64

Ruhmer, 1958
E. Ruhmer, *Cosimo Tura, Paintings and Drawings*, London

Ruhmer, 1966
E. Ruhmer, *Marco Zoppo*, Vicenza

Scharf, 1953
A. Scharf, 'The Exhibition of Old Master Drawings at the Royal Academy', *The Burlington Magazine*, XCV, November 1953, pp. 351–6

Schmidt, 1993
C. Schmidt, 'Una "meditazione sul Cristo morto" di Marco Zoppo' in Vigi (ed.), 1993, pp. 137–46

Schmitt, 1974
A. Schmitt, 'Francesco Squarcione als Zeichner', *Münchner Jahrbuch der Bildenden Kunst*, XXV, 1974, pp. 205–13

Tietze, 1942
H. Tietze, 'Mantegna and his companions in Squarcione's shop', *Art in America*, XXX, pp. 54–60

Tietze and Tietze-Conrat, 1944
H. Tietze and E. Tietze Conrat, *The Drawings of the Venetian Painters in the Fifteenth and Sixteenth Centuries*, New York

Toderi, 1996
G. Toderi and F. Vannel, *Placchette, secoli XV-XVIII nel Museo Nazionale del Bargello*, Florence

Vigi (ed.), 1993
B. G. Vigi (ed.), *Marco Zoppo e il suo tempo*, Atti del convegno internazionale, Bologna

Welch, 1997
E. Welch, *Art and Society in Italy 1300-1450*, Oxford

Whitaker, 1994
L. Whitaker, 'Maso Finiguerra, Baccio Baldini and "The Florentine Picture Chronicle"' in Cropper (ed.), 1994, pp. 181–96

Zeri (ed.), 1987
F. Zeri (ed.), *La pittura in Italia. Il Quattrocento*, Milan, two vols